C000156205

THE BOOK OF ICE

mbp

PAUL D.
MILLER

CONTENTS

I don't know of any studies, but I'd venture that "ice" ranks high on the list of words in the English language most frequently invoked to craft one or another evocative metaphor or insightful analogy. Even cosmology—the science focused on the origin and evolution of the universe—has found ample opportunities to invoke ice. Well, more precisely, ice and the transformations it can undergo. As we all know, water can exist as a solid (ice), as a liquid (liquid water), and a gas (steam). These are known as the phases of water, and the transformation from one form to another is called a phase transition. Such transitions are so commonplace that we take them for granted. But they're remarkable. Based on the properties each manifests, ice, water, and steam seem completely unrelated. And yet, through a simple manipulation of the environment each occupies, we can witness each transmute into the others.

Clearly, even for everyday objects, appearances can be deceptive. The transitions between ice, water, and steam speak to hidden connections—connections lying beneath the surface of appearances that can be central to grasping the true nature of reality. It's a lesson that fundamental physics has recapitulated frequently. Take the four forces of nature—gravity, electromagnetism, and the strong and weak nuclear forces. Every phenomenon we've ever encountered—from Earth's motion around the Sun to your capacity to see these words—relies on processes these forces facilitate. But the forces themselves have vastly different properties: gravity, for example, is billions of times weaker than the electromagnetic force; the nuclear forces, as their name indicates, operate only over the shortest of distance scales. And yet, there is growing evidence that however different they seem, all four forces are fundamentally connected.

Modern physics strongly suggests that in the scorching temperatures of the early universe, the forces would have melded together—like distinct chunks of ice melting into a uniform expanse of liquid water. Just as water and ice are united by their common molecular composition, both consisting of H_2O molecules, so

the four forces, it appears, may be united by shared heritage manifest in the hot conditions of the early universe. As the universe expanded and cooled, the forces went through a phase transition, crystallizing out in different ways from their common substrate, taking on the distinct properties apparent today..

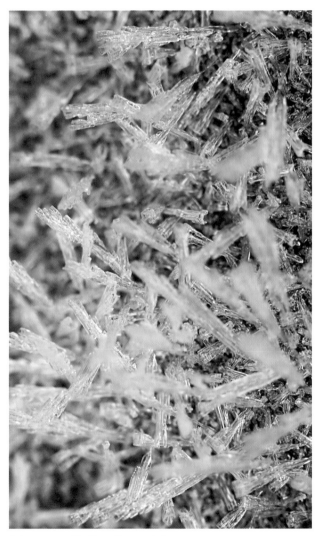

Extreme magnification of ice crystals.

In more speculative areas of physics, such as string theory, yet more exotic versions of phase transitions have also been encountered. Even particular kinds of black holes appear related to elementary particles by such phase transition: certain theoretical models see particular types of black hole and elementary particles as actually two different phases of the same underlying stringy material. Whereas the surrounding temperature determines the phase in which water will exist, the topological form—the shape—of the extra dimensions in string theory (drawn from a class of shapes called Calabi-Yau shapes) determines whether certain physical configurations will appear as black holes or elementary particles.

In one phase, the initial Calabi-Yau shape (the analog of the ice phase), we find that there are certain black holes present. In a second phase, the second Calabi-Yau shape (the analog of the liquid water phase), these black holes have gone through a phase transition—they have "melted," so to speak—into fundamental vibrational string patterns. And as this happens, the extra dimensional shape tears and then repairs itself, allowing the first shape to transmute into the second. In so doing, the process reveals that black holes and elementary particles, like water and ice, are different facets of the same fundamental substance.

While you won't find cosmology or string theory in the pages that follow, you will find an artful ode to ice—literal and metaphorical—crafted in the language of graphic design, using historical photographs and infused with Paul D. Miller's iconic imagination. With Antarctica as its focal point, the book casts a new and different light on this frozen terrain that has long been Earth's most mysterious region. The book amplifies Antarctica's frozen isolation, punctured now with ever greater frequency, and reveals its own set of hidden connections, remixing ice anew.

Brian Greene, author of *The Elegant Universe* and *The Fabric of the Cosmos*

FOREWORD

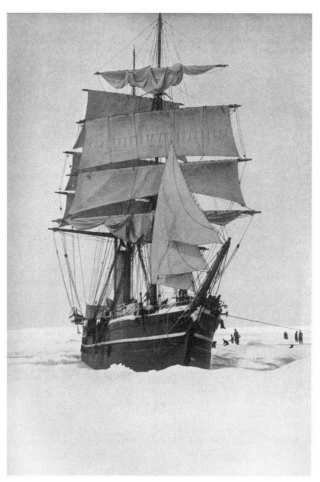

Captain Robert F. Scott's *Terra Nova*; icebound, 1922.

Such was the early public image of Antarctica, a cold and desolate geographic trophy of little value to society. Scientists and explorers explored the periphery of the continent and nations began to carve up this icy world into pie-shaped territorial claims. By the 1950s the Cold War was on, and the US and the Soviet Union each created propaganda proclaiming scientific and political dominance of the continent.

Cold Peace began with the 1959 Antarctic Treaty. Nations agreed to a future of peaceful activities, with no nation able to control any portion of the continent. Science leapt forward and ecotourists arrived in ever increasing numbers. Public awareness of the polar world exploded as news stories reported on global warming and the big melt. Suddenly, Antarctica was a real space. The foundation was set for Paul D. Miller to proclaim the People's Republic of Antarctica. A call to all nations and people to see the coldest, driest, and windiest continent in a new way. Miller spins a multimedia collage of music, art, sound, science, and ice to challenge our sensory and intellectual perceptions of Antarctica. In his artistry, Miller brings new people, new ideas, and new beauty to bear upon a discussion of the future of Antarctica. I invite you to discover what it means to be one of the citizens of the new People's Republic of Antarctica.

Ross A. Virginia, Myers Family Professor of Environmental Science, and Director, Institute of Arctic Studies, John Sloan Dickey Center for International Understanding • Dartmouth College, 2008

[†]*Scott's Last Expedition* Vol. 1, 1913, Smith, Elder & Co, London, pp. 543–44

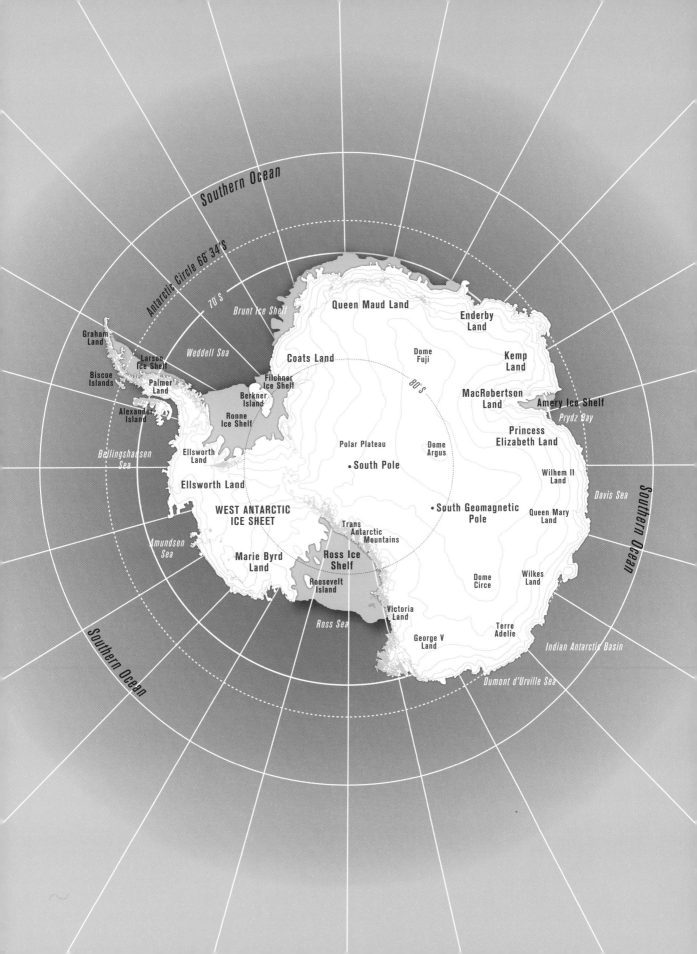

PAUL D.
MILLER

THE
BOOK OF
ICE

When you think of the term "ice" there are so many connotations that come to mind: surface tension, temperature, the opacity of the material, the basic sense that it can transform between liquid and solid. It's elusive because it can become so many things. People use ice for almost every purpose—they make houses out of it, use it in their drinks, land airplanes on it, and if you happen to be in Finland, they make musical instruments out of it.

What I have done with this book is unpack some of the issues that drive my artwork and its relationship to the constantly changing facets of contemporary life in our information-economy dominated, post-everything twenty-first century. Looking back over the last several centuries, an intense amount of energy has been expended all over the world exploring and unraveling the meaning of humanity's condition on the planet. Much of this energy has been spent in perverse and self-defeating ways. Our vision of modern life is tinged by events like the Deepwater Horizon oil spill, which makes former disasters like the 1989 Exxon Valdez incident or the 1986 release of radioactive steam in Chernobyl seem quaint and self-contained. More than ever, we are interconnected, and interdependent. In the future, regardless of any human action, the planet will be here—we, as a species, might not.

If you look back at "ice" in English, you see it's derived from the Old English term "is" that in itself is derived from what most consider to be proto-Germanic "isaz." There are runes for it. There are symbols for it. There is poetry for it. It's considered one of the most mysterious materials, yet in some parts of the world it's simply part of the landscape.

According to most sources in physics, there are fifteen known crystalline phases of water. Ice can exist on other planets in radically different forms, and if you really want to go "macro," you realize that hydrogen is one of the basic substances of the universe. It's that "meta."

Let's put it this way: as a naturally occurring material, ice is a crystalline inorganic solid with what scientists like to call an "ordered structure." It's considered a mineral. Although it is based on the molecule of water, which in itself is made of a single oxygen atom linked and covalently bonded to two hydrogen atoms; many of the main qualities of ice are controlled by the hydrogen bonds between oxygen and hydrogen atoms. Got it? It's the only known non-metallic substance to expand when it freezes. It is less dense than water, which means that ice floats on the surface of any body of water. Light reflecting from ice looks blue because ice absorbs more of the red frequencies of light than the blue ones, so icebergs containing a lot of impurities (algae, rock sediments, air bubbles, etc.) appear grey, brown, or green. Ice's basic structure is hexagonal. Amusingly enough, scientists are still uncertain about what exactly makes ice slippery. From glaciers to pack ice, from icebergs to the undulating surface of what the scientific community likes to call the "cryosphere," ice is an incredibly important part of the global climate, particularly with regard to the water cycle, the basic foundations of life on the planet as we know it. Most scientists would agree that the human body is made of about ninety-two percent water. When we look at ice, we're looking at a reflection of mortality, of the body made solid and inarticulate. One could

WHAT SPHINX OF CEMENT AND ALUMINUM HACKED OPEN THEIR SKULLS AND ATE UP THEIR IMAGINATION?... MOLOCH WHOSE BUILDINGS ARE JUDGEMENT!

—ALLEN GINSBERG, "HOWL!"

say that ice is characterized by ambiguity, openness, and indeterminancy, but is highly structured when it forms. It reminds me of how Eric Dolphy, the jazz musician, described sound: "When you hear music, after it's over, it's gone, you can never capture it again."

Black culture loves ice. We name ourselves after it: Iceberg Slim, Ice-T, Ice Cube. If you're the hip-hop group M.O.P. you can make a song like "Cold as Ice" where you rhyme about "blastin' niggaz" when they sample stuff from Foreigner's hit song "Cold as Ice"—you're as cold as ice, you're willing to sacrifice:

DON'T GET IT TWISTED
I TOLD YOU THAT WE TOP OF
THE LINE, DESIGNED REALISTIC
FOR INSTANCE, MASH OUT POSSE
WILL COME THROUGH AND
CLEAR YO' ASS OUT
DUMP AND AIR YO' ASS OUT
CHUMP, WE COLD

(YOU'RE AS COLD AS ICE)
THAT'S RIGHT
(YOU'RE WILLING TO SACRIFICE)
SHO' NUFF

So, yeah, there's a long history in black culture of being a "cold muthafucka." It's about being a "frigid" person: the ice grill, bling bling, bounce off the light of diamonds in your teeth. Yeah, that's ice.

In 1787 the German physicist and musician Enrst Chladni invented what we think of today as the science of modern acoustics with his book, *Entdeckungen über die Theorie des Klanges* (Discoveries in the Theory of Sound) by using a simple technique of doing things like moving a horsehair bow over a piece of metal whose surface was lightly covered with sand until the surface began to vibrate. This would cause the plate to reach a distinct resonance and the sand

formed a pattern showing the nodal regions. It's an elegant way of illustrating a core issue in modern acoustics by visualizing the situation. Many of the main sound art movements of the twentieth century have been inheritors of the same impulse from Luigi Russolo with his *Arte de Rumori* on over to R. Murray Schaefer with his concept of the "soundscape" to Sun Ra and younger composers like Vijay Iyer with his theory of jazz-mathematics, and Pauline Olivero with her concepts of "quantum improvisation." Basically, amplification for most of the twentieth century has been life lived through the loudspeaker driven by an electronic signal generator over or under the plate to achieve a more accurate adjustable frequency, leading us to the realm that my symphony *Terra Nova* explores.

My concern here is how do we make music out of it, how do we thaw the process, thaw people out, and see the paradox of hyperconsumerism that this kind of stuff celebrates, while at the same time tying the conceptual issues of sound and contemporary art. It's a Sisyphean task, but considering there's not much more going on on this planet than the ecosystem, I thought it was a worthwhile one. Hip-hop is always considered the soundtrack of the city's geometric landscape. The grid of most American cities carries what I like to call an "orthogonal" logic. I wanted to take the "urban" concept of repetition and apply it to a different landscape, and see what would pop out of the collision. After all, music is patterns. And so is landscape. The common denominator here is pattern recognition.

And that's what brings me to Antarctica.

There's always something weird and interesting about how snow and ice form. When you look at snowfall there's a kind of liminal sense of floating, of moving through some kind of crystalline dance that you've learned in another life, but can't recall. Ice and snow are basically geometric forms, and the way human beings interact with them makes for some serious thought on the idea of mathematics in nature. *Terra Nova* was loosely based on things like Johannes Kepler's famous 1611 essay "Strena Seu de Nive Sexangula" (A New Years's Gift of Hexagonal Snow) and the fact that nature has some incredible dynamic movements that are at the threshold of human understanding. Going to Antarctica for me, was a kind of exploration of geological time—through the prism of sampling.

Scientists go to ice fields the way I go to look at my record collection: ice is an archive of data from the planet's hidden past, preserved and ready for playback with the right devices. You could even argue that the grooves of a record parallel the sense of geologic time that is carved into the face of any glacier that has been around for millions of years. All of this leads me to the concept of mapping one concept onto another. I take liberty with a metaphor of what the artist Peter Halley likes to call "indexical realism." Or what I like to call, simply, the mix.

What Kepler explained in his treatise was as elegant as it was simple—thus more complex than his era could really deal with. His observations of hexagonal symmetry in snowflakes extended into a realm of atoms and particles, reflecting his interest in how matter was formed, and how we could "pack" things together using a kind of atomistic arrangement. Think about how that symmetry would sound in music. That's a touchstone for *Terra Nova*. The tone patterns are a kind of evidence, a reflection of a crystalline symmetry in sounds that reflect Antarctic conditions.

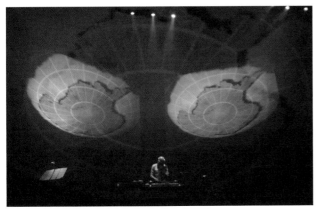

Terra Nova as performed at Multiplicidade in Brazil, November 30, 2010. Photo courtesy of Andre Câmara.

My notes for *Terra Nova* were hand drawn, but my primary sketchpad is digital media; thus, paper is usually an afterthought. If I could have a paperless world, I would! But the fact remained: how do you translate a digital media experience from the studio I carried with me in Antarctica to the kind of acoustic portraits I wanted to evoke with the composition?

The composer Richard Wagner begins his 1849 essay "Das Kunstwerk der Zukunft" (The Artwork of the Future) with a line that I find intriguing: "As Man stands to Nature, so stands Art to Man." I like to think of *Terra Nova* as a twenty-first century update of that observation.

Antarctica represents a place at the most remote extreme of the planet—a place that, by consensus, no nation really owns or controls. In 1959, the world's Great Nations signed a treaty that forbade military use of Antarctic territories, and set the tone for an almost Utopian vision of Antarctica as the last natural place on Earth, unsoiled by humanity. In the fifty years since the signing of the Antarctic Treaty, Earth has seen dramatic climate change—from the massive storms and unseasonal droughts and rains, on over to the large-scale extinction of many species of animals, insects, and fish.

Terra Nova looks at the Antarctic terrain not only through recordings that I made while I was in Antarctica for four weeks in 2008, but through the prism of how music can interpret some of the political and environmental issues facing the continent. The hand-drawn notes for the composition reflect this. They were receptacles for the notes that I didn't feel like typing on my computer. The paper trail for this project was made up of small, cryptic notes meant to trigger associations if I forgot anything. Four weeks in Antarctica feels like a long time, but the way I composed the material while I was there is a reflection of the symmetry I mentioned earlier. It's a composition meant to make you lose track of time, to exist in a prolonged present. The composition explores the linkage of concepts like *Res Nullius* (Nobody's Thing) and above all *Terra Nullius* (Nobody's Land). They are both terms derived from Roman law, posited as a kind of commons. I want to look at Antarctica from the viewpoint of the Antarctic Treaty of 1959 and its relationship to the core issues facing us today. *Terra Nullius*: it's an acoustic portrait of an abstract concept of ice, water, land, climate change, and humanity's relationship to them all.

"Antarctica" comes from the Greek term *antarktikos*, meaning "opposite to the Arctic." The Greeks never went to Antarctica. They just took a wild guess. The Antarctic has many faces: it's usually thought of as a huge pile of ice that somehow stays afloat at the bottom of the globe. In different ages, before humanity had mapped out the world, it would have simply been beyond most maps and most ideas about what made up the geography of the world. More than 170 million years ago, Antarctica was part of the supercontinent Gondwana. Around twenty-five million years ago, Gondwana broke apart and Antarctica, as we know it today, was formed. The ice of Antarctica reflects that. That's why scientists go there to do ice core sampling. When you drill, you pass through millennia of Earth's history in the dust particles, bacteria, and other sundry material.

Antarctica is a commons that we all share, conscious or not, of the history of our planet. That's what I wanted to use as a touchstone for this project.

Today, concepts like "land" and "territory" are becoming more and more abstract—the internet has radically changed the way we relate to both concepts. The "commons" in our information-economy-based global culture is just as intimately linked to climate change in Antarctica as anywhere else in the world. Imagine the continent before people like James Cook (who "discovered" more land than any human in history with his three voyages around the world), Robert Falcon Scott, Roald Amundsen (widely credited as the first to reach the South Pole), Douglas Mawson, and Ernest Shackleton. *Terra Nova* references Scott's tragic 1910–1913 Terra Nova Expedition, which ended in the deaths of most of the explorers involved. Time and again, explorers tried to conquer Antarctica. With scenarios like the Shackleton Imperial Transantarctic Expedition or the German *Neu Schwabenland* (New Swabia), where the Luftwaffe flew over Antarctica in 1938 and dropped Nazi flags in attempt to claim the continent, the idea of land claims meets the collapse of the nation state. Antarctica was the blank space at the edge of the imperial map of competition amongst the great powers. It's easy to see the continent as the home to a hypothetical revolution inspired by science fiction writers like Kim Stanley Robinson and Bruce Sterling.

For most people, Antarctic exploration typically centers on dogs, skis, snowshoes, and people in fur—not paintbrushes or sketch pads. Actually, art has always had a prominent place in the exploration of Antarctica. Photography began in the 1830s, but only in the late nineteenth and early twentieth centuries was it possible to take photographs in cold environments. Therefore, it was common for explorers of polar regions to be accompanied by artists to visually record the sights and phenomena for research and popular distribution in books and articles. In the modern era, artists continue to venture to Antarctica. Their intent is not simply to record but to provide visual interpretations of the continent, based on direct observations combined with artistic talent. Before humanity had mapped out the world, it would have simply been beyond most maps and most ideas about what made up the geography of the world. As such, the Antarctic is one of the most unknown territories in the world today. For the purposes of this project, the idea of looking at the places beyond the realms of everyday life in the industrialized twenty-first century world puts

the continent front and center into the idea of making a map of the continent in sound. Frank Hurley's photographs of the Terra Nova Expedition and the fact that he, along with the German Drygalski expedition of 1901–1903, was one of the first people to bring a phonograph to Antarctica factor into the visual and audio material that make up this book.

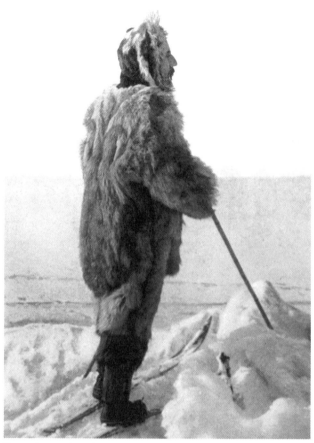

Norwegian explorer Roald Amundsen in ice. From 1910 to 1912 he led the first Antarctic expedition to the South Pole.

With *Terra Nullius*—the legal concept of land considered "ownerless" property is usually free to be owned—we face an almost science fictional landscape where all the definitions we usually use to shape and mold "consensus" of the nation state are left far behind. How do we portray that in music? For me, the music composition I made while I was in Antarctica is kind of a document of collective memory and a meditation on what happens when we remove the idea of ownership. I guess you could call it a post-colonial composition.

How do we interpret landscape in the form of song? In 1905, Debussy wrote his famous composition *La Mer*.

The way Debussy captured the ocean's color, light, and mood—using the orchestra as his paintbrush—gave composers new ways to think about writing orchestral music. In the twenty-first century, my composition *Terra Nullius* looks at other works that reference landscape—John Cage's 1948 *In A Landscape*, George Frederic Handel's *Water Music* of 1717, and Wagner's concept of *Gesamkunstwerk* as inspirations for new forms of composition. There are other compositions that I reference in the piece as well: Charles Ives' *Central Park in the Dark*, whose collage based aesthetic implied that the listener had heard glimmers of sound from every angle of the park; artist Annea Lockwood's *A Sound Map of the Hudson River*; and above all Ralph Vaughan Williams' 1948 *Sinfonia Antarctica*, the first symphony to be written about Antarctica. There is also the composition by British composer Peter Maxwell Davies, *Symphony No. 8: Antarctica*, written in 2000.

But there are other influences for the connection between making a high-definition film and symphony about ice. One of my favorites is Cornelius Cardew's composition from 1963, *Treatise*, the longest and most elaborate piece of music written as graphic design ever made. It's 193 pages is mainly circles, dots, and lines: they are commands to musicians to interpret the density of texture in the sounds for whatever instrument the musicians want to engage. Along with Anthony Braxton's symbol systems, I wanted to think about the digital effects of the material I created as an update on both ways of thinking about sound and landscape. The Antarctic landscape is defined by geometry, rupture, and massive complexity.

Each of these composers explored the realm of nature through the prism of composition. And like some of the art movements at the beginning of the twentieth century, they faced an aesthetic revolution. Impressionism, Futurism, Surrealism, Cubism… you name it, the music of the era was a mirror reflection of social and political upheaval. In the twenty-first century, the analogy still holds. Music is a mirror we hold up to society. I reference Debussy, because for him, like myself, music was a kind of palette; the analogy of comparing music to painting is just a form of a new way of thinking about digital media's inheritance from previous avant-garde movements. Like the Impressionists, Debussy conjured his imagery not in a sonic blur but from seemingly disparate but carefully arranged flecks: move close to any Impressionist painting and the misty atmosphere ripens into a mosaic of intensely colored fragments.

That is where the subtle sense of layer and collage that informs his work connects with contemporary ambient forms of music like *Terra Nova*. And, like the Impressionists, Debussy's work suggests open-air sketches in its seeming naturalness and spontaneity, and its inspiration in nature. What happens if we apply the same concept to the remote Antarctic landscape? The *Book of Ice* relishes the uneasy tension between the legible and illegible, the machine print of the blueprints and graphic designs that I created while I was thinking about Antarctica. The material in this book needs to be engineered, and drawn. It's a metaphor like the art critic Alfred Barr's charts showing the complex relationships of aesthetic movements, but through the prism of sound. It's a diachronic and synchronic unfolding drama of the hand as it seeks to become digital. Goethe once wrote: "architecture is nothing but frozen music." *The Book of Ice* seeks to reverse engineer the process and thaw it: it seeks to pull this crystalline architecture of graphic design, film, photography, and music into the realm of liquid sound distilled pure from the Antarctic landscape.

Paul D. Miller
Saas-Fee, Switzerland 2010

THE CAUSES AND EFFECTS OF CLIMATE CHANGE

Water sustains us but it can also destroy us if we do not act responsibly. Terminology (open source) taken from "Kick the Habit," a United Nations guide to climate change.

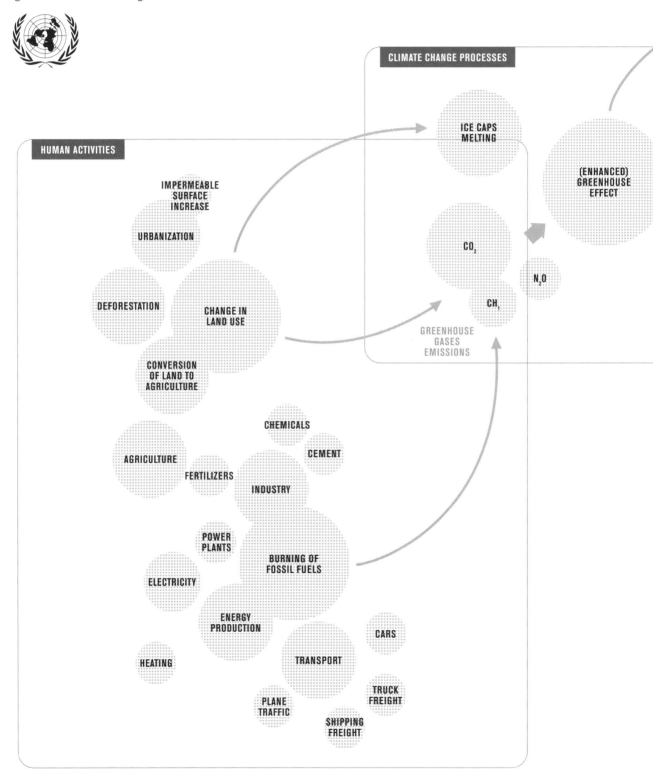

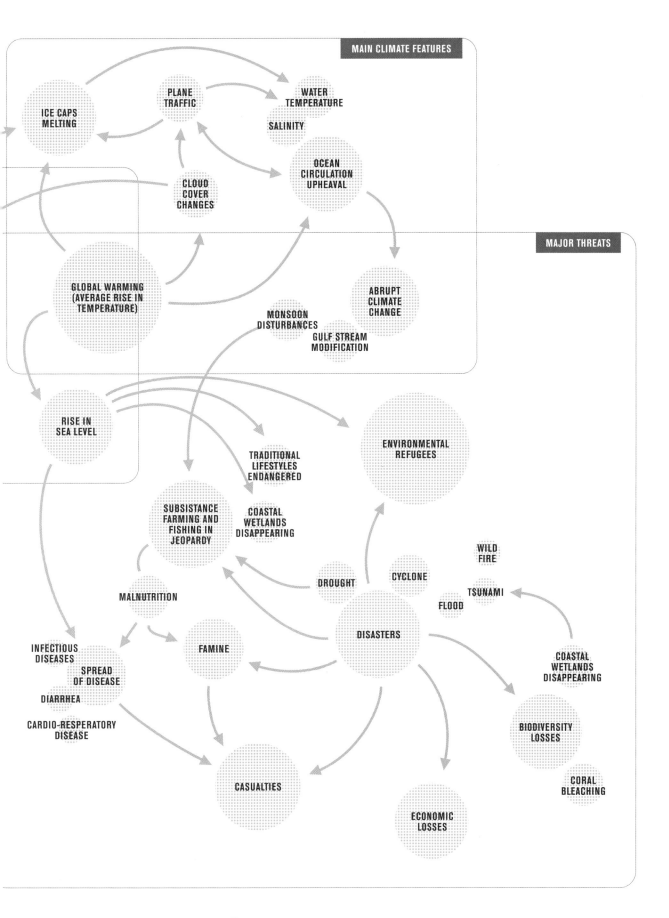

PLANE
TRAFFIC

WATER
TEMPERATURE

SALINITY

ICE CAPS
MELTING

CLOUD
COVER
CHANGES

OCEAN
CIRCULATION
UPHEAVAL

GLOBAL WARMING
(AVERAGE RISE IN
TEMPERATURE)

MONSOON
DISTURBANCES

ABRUPT
CLIMATE
CHANGE

GULF STREAM
MODIFICATION

RISE IN
SEA LEVEL

TRADITIONAL
LIFESTYLES
ENDANGERED

ENVIRONMENTAL
REFUGEES

SUBSISTANCE
FARMING AND
FISHING IN
JEOPARDY

COASTAL
WETLANDS
DISAPPEARING

WILD
FIRE

MALNUTRITION

DROUGHT

CYCLONE

TSUNAMI

FLOOD

INFECTIOUS
DISEASES

FAMINE

DISASTERS

COASTAL
WETLANDS
DISAPPEARING

SPREAD
OF DISEASE

DIARRHEA

CARDIO-RESPERATORY
DISEASE

BIODIVERSITY
LOSSES

CASUALTIES

CORAL
BLEACHING

ECONOMIC
LOSSES

15

SONIC LANDSCAPE

The Canadian composer, educator, and environmental activist R. Murray Schafer is perhaps best known for his use of the term "soundscape." For him it implied a connection between how sounds evolve in acoustic space and how human perception connects the sonic phenomena around the observer. I am interested in the connection between graphic design components like the "soundscape" and how we can perform a composition. Turntables, and now any digital playback device, create sound fields, or personal sonic spaces. This is a visual exploration of that phenomenon.

In 1969, Schafer also coined the term "schizophonia." He used it to describe the phenomenon of splitting a sound from its source or the condition caused by this division from the natural to the artificial representation of a sound from its origin—this is the essence of sampling. Schafer wrote: "We have split the sound from the maker of the sound. Sounds have been torn from their natural sockets and given an amplified and independent existence. Vocal sound, for instance, is no longer tied to a hole in the head but is free to issue from anywhere in the landscape." This section explores this theme through visual sampling.

PAUL D. MILLER DISCUSSES HIS ANTARCTICA FILM AND GALLERY EXHIBITION WITH ELENA GLASBERG, PROFESSOR, PRINCETON UNIVERSITY

 ELENA GLASBERG

 PAUL D. MILLER

When did Antarctica emerge into your world? Do you recall images? Was it fiction or learning of historic exploration figures?

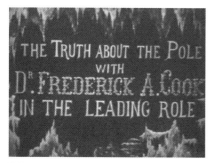

Title from Frederick A. Cook's film _The Truth About the Pole_.

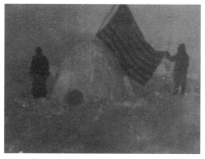

Photo from Frederick A. Cook's alleged 1909 arctic expedition.

I guess some of my most formative film experiences come from early cinema pieces like Méliès' 1902 _The Conquest of the North_ and the "false" history of Frederick A. Cook's 1912 _The Truth About the Pole_. I used to watch old films whenever I could, so I'd catch this kind of strange dualism. Like the Lumière brothers, Cook's film tried to portray itself as a realistic, almost documentary kind of scenario. I usually prefer the other school of thought. Méliès started out as a magician who wanted to apply magic technique to film. The two films are about the opposite side of the planet from Antarctica, but they're both amazingly, eerily prescient about how discovery and the "voyager's path" would then take on almost surreal proportions. That's a similar motif for my _Terra Nova_ and _Manifesto for a People's Republic of Antarctica_ projects. They both use found footage, print design, and propaganda to show how exploration at the edge of the world is a prism to view how nations look at one another, and how art itself is a highly politicized medium. I guess you could say I'm inspired as much by Jules Verne as I am by the exploration of the film _90 Degrees South_ by cinematographer Herbert G. Ponting, who was one of the first people to get footage from Antarctica.

So much of my work comes from the hard-learned truth that collage speaks across many borders, cultures, and, yes, economic classes: if you want to deal with hip-hop and then give a lecture at places like Yale or Harvard, you really have to be prepared to speak in academic pidgin as well as be able to flow in the club scene, etc. I never really thought of myself as separate from the normal art and academic works that I create. My books, art shows, and exhibitions are driven by the obsession I have with saying that multiculturalism, market forces, and the basic fabric of the Enlightenment are interconnected. One of my favorite recent books, _Capital and Language_ by Christian Marazzi, talks about hoarding as a way to engage some kind of logic of culturally produced value. I am always astounded at how little the art world understands the kind of cultural economy that DJ culture emerges from. Nothing, after Wagner's concept of _Gesamkunstwerk_ exists in a vacuum: whether our culture is now taken from YouTube or posted online with cell phones by soldiers in Iraq, we exist in a world where documents act as a kind of testimony. But once something is recorded, it's basically a file waiting to be manipulated. That's what links the concept of the remix to everything going on these days: truth itself is a remix. Anyway, it's all about a new kind of relativism.

What do you think of Vaughan Williams' *Sinfonia Antartica*, both as music and as an historical artifact of an Antarctic vision?

Vaughan Williams, it's well documented, was preoccupied with the concept with the "end of empire" and the end of World War II. I really think that's when the concept of the British Commonwealth needed to be reexamined, and if you look at the Indian liberation project of Ghandi and Indian independence in 1947, that kind of stuff must have really been foremost on the mind of the generation of composers that needed to give the British something to think about after the war. What had the war been about except imperial ambition? By making Robert F. Scott, someone who had died in service to the Empire, the film *Scott of the Antarctic* really set the tone for how the twilight of the British Empire needed to look for new heroes. Let's not forget that the first composition to really engage Antarctica started as a soundtrack for Vaughan's score to the film. The Vaughan soundtrack, like the original music composed by Joseph Carl Breil for D.W. Griffith's film *Birth of a Nation*, was a pastiche of themes and motifs that would speak to a film audience. I wanted to update the same concept with turntables and digital media. I really don't think of music, film, and art as separate. There is a seamless connection—it's the creative mind at work.

I'm interested that you actually went to a part of the Antarctic by boat from South America. How did your conception of Antarctica as a place affect what you saw there? What was the most surprising aspect of being in Antarctica?

I went to several islands and ice fields that were near the Antarctic peninsula but a little further down on the continent. I'll be going back in a while to check out more of the interior. We chartered a Russian ice breaker called *The Akademic Loffe*, and the next time I go, I'm going to try and get to the Lake Vostok base. The most surprising thing about Antarctica was the stench of penguin shit. You can smell them a mile or so out in the water! I live and remember it all. The idea of the journey, if you look at Méliès's film *The Conquest of the North* from 1912, is still with us. It's now just hyperrealism.

Do you think people have a place in Antarctica?

No.

Why do people need to hear Antarctica? How does this mode distinguish itself from seeing Antarctica, which has been the overwhelming mode since the turn of the last century and the accident of near simultaneous advent of film photography and embodied access to the inner

Everything is I do is about paradox. It makes life fun. I think that people need to hear Antarctica because it is at the edge of the world. The technical terms heterodoxy and heterogeneity both find a solid home in me and my work. I celebrate that kind of thing. One day, the software we use and the life we live will blur. It's kind of already happened. But that's why I go to places like Antarctica. New York is probably one of the most mediated places on earth. If I have a conversation at a café, someone will put it on a blog. If I walk down the street, someone puts photos of it on

continent? How do you see your mixed modes of approach, embodiment and digitized representation, in the context of the history of representing what is arguably the most mediated place on earth?

Flickr. It's irritating, but it's the way we live now. Antarctica represents a place mediated by science. It's literally almost another world. Some of my favorite science fiction, like Kim Stanley Robinson's *Antarctica* or Crawford Kilian's *Icequake*, deals with Antarctica using some of the same themes: science, art and the weirdly un-worldliness of the ice terrain. I think of that kind of stuff as an update of the speculative visions of Verne that inspired Méliès with his earlier films. My film *Terra Nova* and my *Manifesto for a People's Republic of Antarctica* are in the same tradition. These projects are all about taking music from the edge of the physical environment and music from the core of the urban landscape and combining the two. Watch them collide in paradox.

You work among a wide variety of audiences, purposefully and joyously erupting into places not usually associated with DJ culture, beats, aural sophistication, and academic-style intellectualization. Where do you place Antarctica within your work and audience?

I have a degree of comfort with new places in this hyper-turblulent and digitally abstract contemporary life. Life is hybrid and always has been. It's just that digital media is making us realize that it's not about the "end of Western culture" because of multiculturalism, etc. It's actually giving Western culture a place in whatever else has been going on. Which is healthy. I just roll with it all. Edward Saïd's critique of Western classical music as a kind of involuted *samizdat*, rings true for my work. I really think that the distinctions that defined most of the twentieth century are almost gone. Technology has moved far more quickly to transform our social structures than anyone could have anticipated. DJ culture accepts this and celebrates it precisely because it's not linked to the production of objects. It's obsessed with continuous transformation, and that's where I live. In total flux.

You are intrigued by Antarctica's geopolitical exception, its lack of indigenous and its never-nationalized status now under the 1959 Antarctic Treaty System. I see this reflected in your playful echo of the title of a 1981 novel by John Calvin Bachelor, *The People's Republic of Antarctica*, in your poster series. How do you see Antarctica as an exception to global politics? Is it a demonstration of alternative possibilities to history? What vision of propaganda inspired the poster series?

If you look at twentieth century advertising, it's the hidden architecture holding both capitalism and communism together. Everyone had to get their message out! Think of this: Alexander Rodchenko said in 1921 that he "reduced painting to its logical conclusion and exhibited three canvases: red, blue, and yellow," and affirmed, "this is the end of painting." What a great statement! Whether it was Stalin, who said that "engineers are poets of the soul," or Chairman Mao, who put teachers in chains and paraded them as false prophets, the kind of "stay on message" type ethos dominated the media discourse of every nation. With the *Manifesto for a People's Republic of Antarctica* prints and my film projects, I simply ask the question: what if the nation state went away? What centrifuge would we all then call home? What would be the point of looking at the state as a kind of generative architecture? Who would be commissioning the designs, who would be fostering the arts?

The answer: corporations. I use the ironic motif of stuff like the British East India company or some of the ways that we have corporate sponsorship of exploration and high endurance sports as examples. If you look at Rodchenko's designs or Malevich's early minimalism, you can see an echo of that in my work. The revolution for the US after the fall of the Berlin Wall was untrammeled capitalism. Look around and see what it's done for us! The only competing ideology at this point is radical Islam. I'm not so sure that people would like to embrace Sharia economics, but if they look at the Middle East, there's lots of solid banking going on (unlike Wall Street recently). I guess you could say that my work is kind of an aesthetic futures market where any sound can be you. That's what sampling is about. The *Terra Nova* and *Manifesto for a People's Republic of Antarctica* projects are mirrors held up to a world that is melting. I don't know about you, but I think it's a pretty strange mirror to see oneself in. I read John Calvin Batchelor's book and enjoyed it, but aside from "sampling" the title (I do this a lot!), there's not much of a connection, except that his book is a meditation on the end of norms of governance.

How are you creating the sounds of Antarctica? What is the technical process and how does it reflect Antarctic representation, its many challenges, and its history?

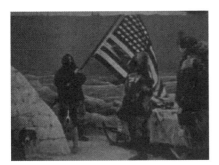

Still from Frederick A. Cook's film *The Truth About the Pole*.

My installation is loosely based on the "false" story of Frederick A. Cook, who went north. *The Truth About the Pole* (1912) was a self-promotional docudrama in which producer Frederick A. Cook sought to have himself treated as a heroic adventurer who discovered the North Pole, a claim he'd been making since 1909. No director wanted credit for making it. Cook plays the starring role as himself. There is at least one appealing set that attempts to be naturalistic, showing a frozen ship in the distant background. Mostly it all looks pretty hooky. It's interesting how little one needs for a quick jaunt to the Pole: a logbook, sled, and an American flag being the whole of it. All you require to recover from such an easy stroll is a nice wooden hut and one sip of coffee from a tin cup. A silent film villain, Harry Whitney, is the evil scoundrel who started the rumor that Cook's former claim to have climbed Mt. McKinley was a fabrication. This was (according to the revisions proposed by his film) Whitney's newest salvo in a campaign to make Cook's polar expedition appear to have been a hoax. I think it's hilarious. I repurpose this kind of thing, and flip it into the South Pole. Who owns the ice? Who owns the memory of the ice? My composition for the installation is based on gamelan music from the idea of "shadow theater" mixed with string arrangements taken from my score to *Terra Nova*. Debussy, after all, was inspired by gamelan, and I guess you could say ambient electronic music is about as Impressionist composition as you can get. I like the idea of ambiguity. It keeps you on your feet, makes you think about paradox and the digital world of

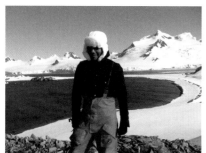

Paul D. Miller in Antarctica.

relativity we live in today. When I went to Antarctica I wanted to have a place where there was essentially a fresh perspective and where I really needed to think about how I would interact with the environment in a way that would free up some of the issues that drive normal hip-hop. The sounds in my projects come from nature: wind, water, the noise of feet walking on ice. My project takes those sounds and uses them as an acoustic palette. I mixed and remixed the material to the point that bass lines come from wind and water movement, and the sound of human breath can be a motif made into some kind of strange pattern. The score for *Terra Nova* was written in a much more conventional way, but that's why I like to say I'm into paradox. You could almost say that it is neo-Baroque, just on the edge of when everyone thought that the Age of Reason had dealt a death blow to superstition in Europe. I guess you could say that my project is about the sound of science.

I'm struck by the influence of Gore's documentary *An Inconvenient Truth* on subsequent representation of the Antarctic, of all the computer graphic simulations of melting ice sheets in a pristine and remote Antarctic and the resultant rises in sea levels of very well known urban locations. Do you see your work in such a context of politicized—or catastrophic—simulation?

I'm a big Paul Virilio fan. Let's call *Terra Nova* in terms of theory speak (it's just a different pidgin language after all): trajectories of the catastrophic, or pure war. Antarctica isn't a place: it's a location. It's kind of like saying Buddhism isn't a religion: it's a philosophy. Everyone knows that, but they still get it wrong. I always try to get people to think about conceptual frames of reference; context is important in my work, and so is content. How do you establish an uneasy tension between context and content when everything can be remixed and changed, and there's no final version of anything? In *Terra Nova*, that kind of graphic design imprint is crucial to how the story is told. If you look at the old Terra Nova expedition of Robert Scott, you can only think: wouldn't it have been great if they had satellite footage to tell them they weren't that deep into the ice, and to compare some different routes to get out of the drift their ship was caught in. Stuff like Apsley Cherry Garrad's infamous *The Worst Journey in the World* where he says "Polar exploration is at once the cleanest and most isolated way of having a bad time that has ever been devised." That's one of the most succinct ways one could put this simple observation. Melting ice sheets look cool, but then again, so do solar flares on the surface of the sun. They're both harmful, but hey, art makes things look cool.

Your film debuted at the 2008 democratic national convention. What did you want Obama to see, to respond to, and to promote in his administration?

I really think it's time to say goodbye to the twentieth century. So yes, the Obama convention with Dialog City as the focal point for the contemporary art scene was a breath of fresh air for me. I really liked premiering my film at the Denver Opera House. The Colorado art scene is a lot more progressive than the one in New York! I think Obama will probably be one

of the greenest presidents since Jimmy Carter put solar panels on the White House. The Republicans went crazy, but in hindsight, it was really, really, really cool. I like stuff like that. That's why I premiered *Terra Nova* at the Democrats' convention. I think of the film as a reflection site, a location for the politics of perception that we use to look at the environment.

RISKS AND IMPACTS OF GLOBAL CLIMATE CHANGE

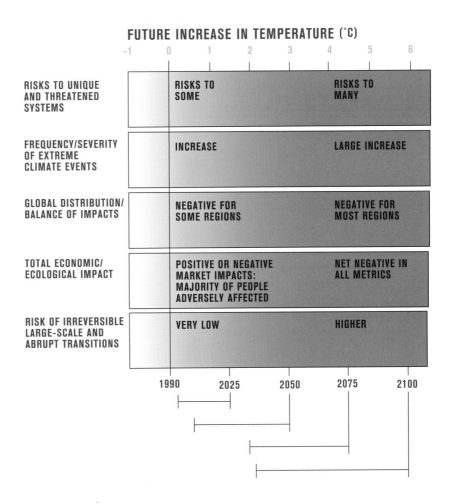

FUTURE INCREASE IN TEMPERATURE (°C)

Antarctica and in particular the South Pole have been fantasy objects for US and European imperialism since the early 1900s. Authors populated the unknown south with wishful fantasies of lost races, arable lands, and mineral wealth. Post-colonial nations such as Argentina, Chile, and even Malaysia have fought and argued to be included among the arbiters of Antarctica's possible riches. How do you negotiate nationalism and the history of imperialism in your own approach to the territory?

You really have to think about Antarctica as a terrain of possibility. It's a surface we project onto, but it doesn't reflect back. I always think of the Bruce Sterling's phrase, the suicide bomber is the poor man's cruise missile. There's always going to be conflict over resources as long as people think everything is completely limited. The weird thing about the twenty-first century is that we have perspective. That's something the warring empires of the past didn't have. We have history, comparative science, and above all, a sense of urgency with regard to global warming. And guess what: we still can't get it together. Some of the best recent films dealing with Antarctica, like Werner Herzog's *Encounters at The End of The World* or the anti-whaling film *At the Edge of the World*, both have this kind of "rebel/misfit scientist" take on the expatriate community that lives in Antarctica. The cracks in the mirror are where some of the best images are to be found. Antarctica, for me, is just a really big crack in the way we look at the land claims of the Great Nations. I really think that my film project is a cinema-scape in the same tradition of Nam Jun Paik, John Cage's "Imaginary Landscape" or Edgar Varese and Scriabin's visual essays turned into sound. Imperialism is such a concrete process: take the land, brainwash the natives, make the people back home think it's all being done in their name. The problem with the twenty-first century for that kind of schemata is that no one really believes it any more. It's just one fiction of many. I tend to think that's a good thing. It's time for a fresh kaleidoscope! We need more paradox than we can possibly know right now. And Antarctica is the place to manifest that kind of paradox. After all, it's the end of the world. I want us to look over the edge.

Most will never see Antarctica. How do you want them to think of their relation to this remote and highly mediated territory? Do you feel that you're operating with a blank screen, or do preconceptions of the region cloud collective action?

How do people hear Antarctica? It's a question that lingers over this interview. Unmoored, unleashed, free floating—sampling derives its sense of cut-and-paste aesthetics from the interplay of the kind of "rip, mix, and burn" scenario of the twenty-first century information economy. But there are so many cultural resonances that kick in when we think about appropriation art. In 1964 Ralph Ellison read a statement at the Library of Congress about the possibility of an artform made of fragments. The lecture was called "Hidden Name and Complex Fate" and basically it was a manifesto about a series of poems and music that was made into a "mix" of music that influenced him. It was kind of a "sonic memorial" made of fragments from artists and composers as diverse as Duke Ellington, Louis Armstrong, Bessie Smith, Mahalia Jackson, but the selection was meant to be a literary scenario that evoked music as a kind of text. Of the jazz legends he invoked in his discussion, he simply wrote that "the end of all this discipline and technical mastery was the desire to express

Paul D. Miller notebook.

an affirmative way of life through its musical tradition... Life could be harsh, loud, and wrong if it wished, but they lived it fully, and when they expressed their attitude toward the world it was with a fluid style that reduced the chaos of living to form." This kind of hybridity is something that drives my work. I'm inspired by the destruction of old, boring, ways of thinking and feeling, by the casting into the flames of obsolence all the stupid old categories that people use to hold the world back from the interplay of uncontrolled "mixing." Yeah, I say, we need to mix and remix everything. There is no final version of anything once it's digital. Is this a mirror we can hold up to society in the era of information overload? Antarctica is a realm of possibility because put simply, very few people are aware of its story. That in itself is a rare and elusive quality that the beginning of the twenty-first century has brought front and center into modern perspective: there's strength in invisibility. You have to think of the landscape and the way artists interact with it. John Cage's *Imaginary Landscape* from 1939 was composed of records playing frequencies. But if you look at *In a Landscape*, from 1948, you can easily see early taste for percussion instruments and "found sounds," as well as his interest in embedded, recursive rhythmic structures, while the last two of the series, composed in 1951 and 1952, exhibit the influences of Cage's experiments with various kinds of precompositional chance operations. I think that is what resonates with Antarctica for me: the space to be sonically free. After all, it's the only place on Earth with no government. What's the soundtrack to that?

Elena Glasberg has been thinking about Antarctica since the day she encountered Edgar Allan Poe's *The Narrative of Arthur Gordon Pym of Nantucket*, an 1828 vision of a polar abyss. Beginning with this inconclusive end to the mapped earth, Glasberg studies the way nation, science, and literature continue to produce the territory with the least sure future on Earth.

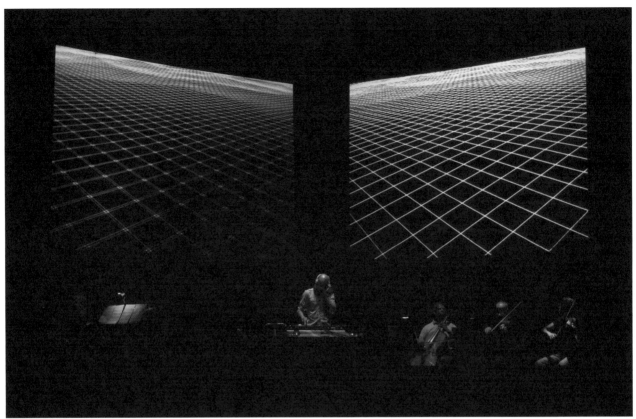

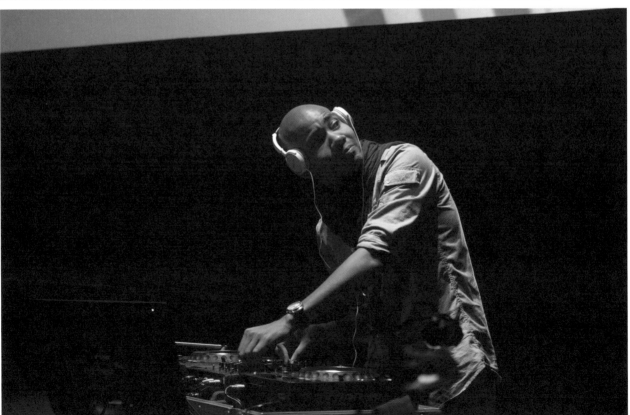

Terra Nova as performed at Multiplicidade in Brazil, November 30, 2010. Courtesy of Rodrigo Torres.

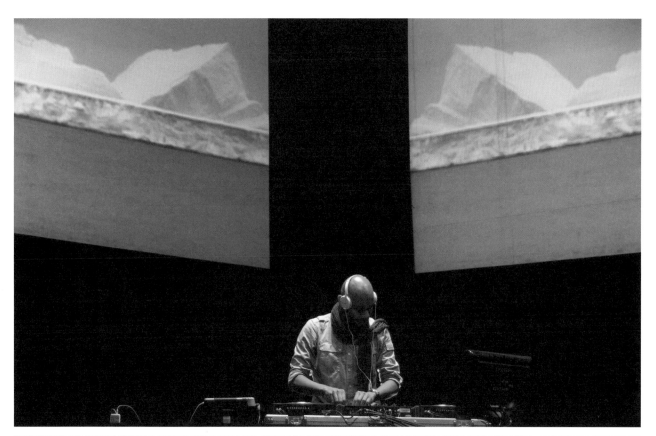

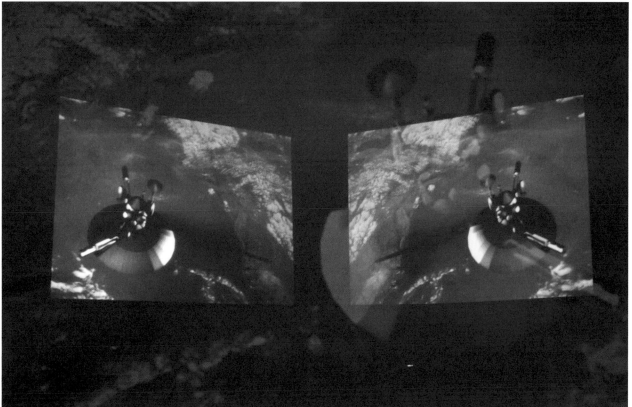

Terra Nova as performed at Multiplicidade in Brazil, November 30, 2010. Top: courtesy of Rodrigo Torres; bottom: courtesy of Diana Sandes.

DATA LANDSCAPE

How do we read a landscape? What is the text of any given landscape? Some of the inspiration for the work in this section comes from sources as disparate as the appearance of geometric forms that appear on *tapa*, or bark cloth, that is used to create social rank and status in the South Pacific to the geometric patterns that appear in the Arctic and Antarctic terrains that I've traversed while looking for material to appropriate for my musical compositions.

The twentieth century was, in musical terms, an incredibly noisy time, from George Antheil's *Ballet Mechanique* to Scott Joplin's wild ragtime compositions, Igor Stravinsky's *Rite of Spring*, John Coltrane's *Om*, or Jimi Hendrix's Woodstock remix of the American anthem. The artwork in this section looks at the idea of music not as music. But as information, referring to a tradition that twentieth-century composers embraced as a conceptual framework that changed the way we view composition. In a sense, these pieces are sounds—environmental, industrial, often random—as much as portraits. They lay siege to inherited notions of musical order. If last century's avant-garde taught us anything, it is that "disturbances" in the natural order of how people view music belong in the realm of art.

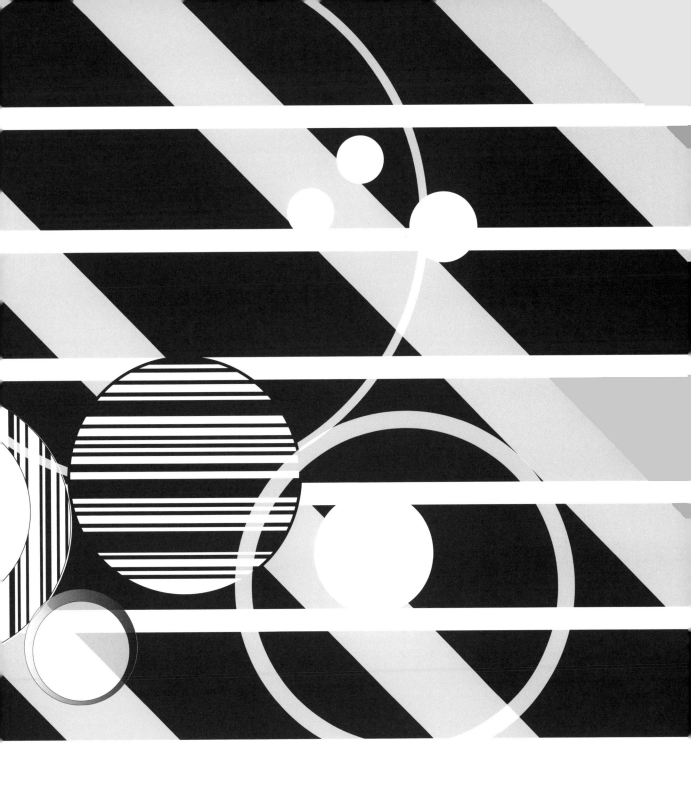

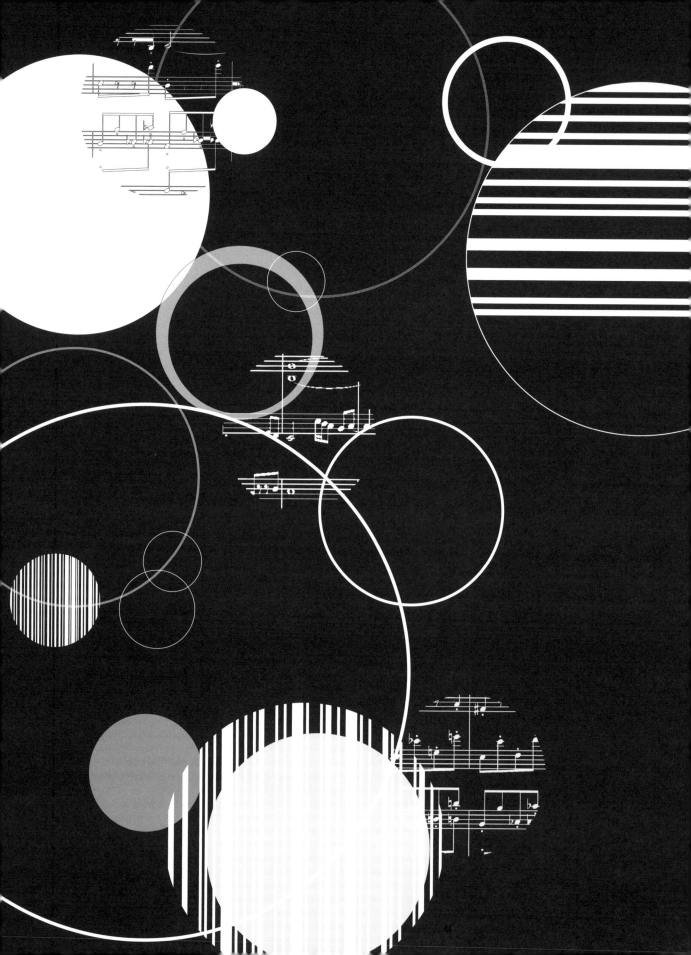

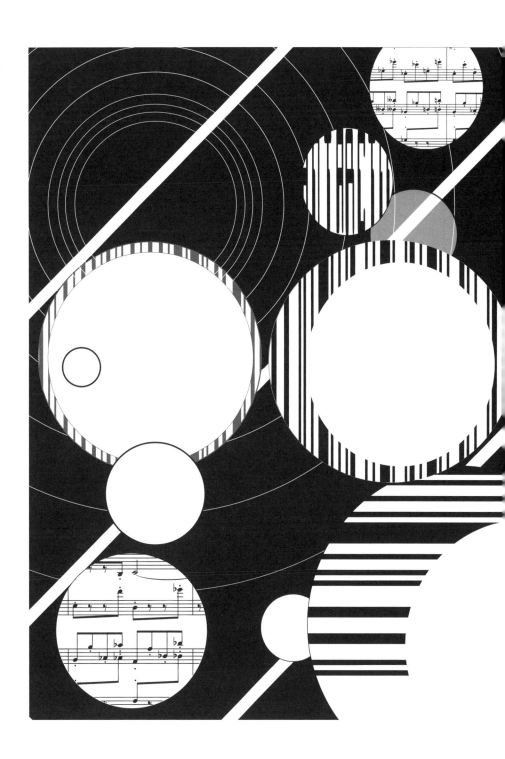

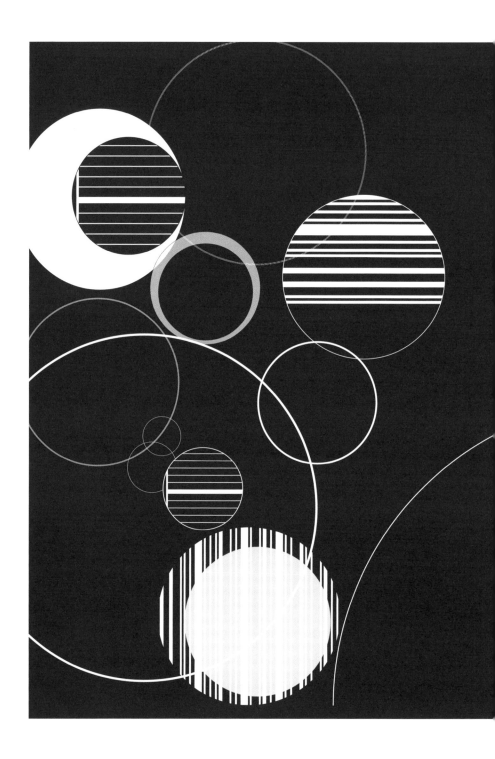

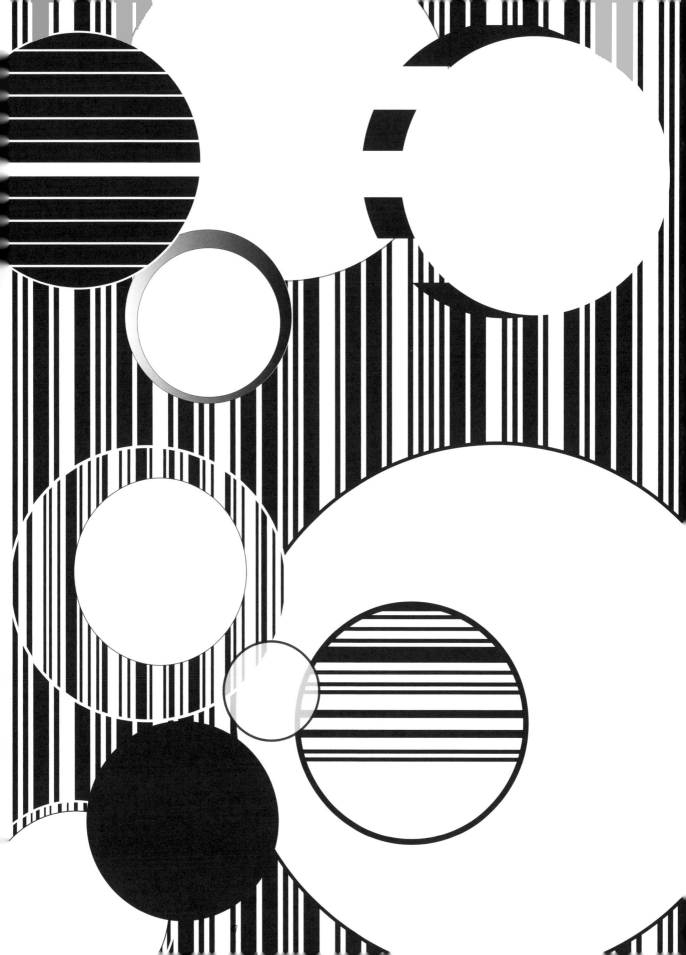

TIMELINE OF ANTARCTICA

As place and concept, since its original crystallization in the myths of the Ancient Greeks, the chill landscape of Antarctica has loomed at the periphery of the human vision of the world. At times a frontier, a promise of fame, a non-National sanctuary, and a slowly melting monument to the time before the Anthropocene, the continent of ice has been explored in increments. The story of that exploration is told in storm-blown ships, pack ice, frostbitten limbs, and horizons opened by technology.

CIRCA 350 BC

The Ancient Greeks first come up with the idea of Antarctica. They know about the Arctic—named Arktos (the Bear)—from the constellation the Great Bear and decide that for order and symmetry to balance the world, there should be a similar cold southern landmass that was the same but the opposite: "Ant-Arktos" simply means "opposite the Bear." The Greeks conceptualized the term, but they never actually went to either the Arctic or Antarctic.

CIRCA 330 BC

Pytheas of Massalia, a Greek merchant, geographer, and explorer, navigates the coast of Britain and the waters north of Scotland. He describes an island six days sailing north of Britain and names it "Thule." This could refer to Iceland, but it could also have been the coast of the Shetland or Faroe Islands, or Norway. Pytheas is the first person to record a description of the midnight sun, the aurora, and polar ice.

1409

A revolution in oceanic navigation occurs when Ptolemy's *Geographia* is translated into Latin, thus introducing the concepts of latitude and longitude to Western Europe. This allows for long distance sailing, and the creation of more precise methods of charting the positions of ships over immense expanses of the ocean.

JUNE 7, 1494

The Treaty of Tordesillas is signed by Portugal and Spain, dividing the known world defined by the Atlantic Ocean between the two powerful kingdoms. Pope Alexander, VI presides over the division, with Spain taking the west and Portugal the east. Antarctica is not mentioned. The rest of Europe does not recognize the treaty.

SEPTEMBER, 1519

Ferdinand Magellan sails from Spain in search of a westerly route to the Indies. Navigating down the coast of South America, he discovers the narrow strait passing through to the Pacific Ocean that today bears his name. Further south lies Tierra del Fuego, which the early geographers assumed to be the edge of the southern continent, representing the edge of the world as they knew it.

1578

Francis Drake passes through the Straits of Magellan. He finds himself blown significantly southward due to a tremendous storm in the Pacific. This event proves that Tierra del Fuego was separated from any southern continent. The resulting discovery comes to be known as the "Drake Passage."

1592

Sailing on the *Desire*, Englishman John Davis discovers the Falkland Islands. The crew is forced to eat over 14,000 penguins, which they killed for food in order to survive the winter. Stored as properly as possible, upon reaching the tropics the penguin meat spoils—only sixteen of the original crew of seventy-six reach home.

1594–1610

A major motive for the exploration of the Arctic was the relentless economic competition and the quest for additional trade and commerce and the desire of European states to find alternate trading routes to China, in the form of either a Northwest Passage along the coast of North America, or a Northeast Passage along the coast of Siberia. A similar impulse leads to further exploration in the southern hemisphere.

1611

Johannes Kepler publishes *A New Year's Gift: or On The Six Cornered Snowflake*, a mathematical treatise on why snowflakes form a hexagonal structure based on algorithmic analysis of how snowflakes are unique manifestations of a formula. Each snowflake is an expression of mathematics implicit in the foundations of nature.

1675

Antonio de la Roché is blown south of Cape Horn giving him the first sighting of South Georgia.

1739

Jean-Baptiste Bouvet de Lozier discovers the island Bouvet. Due to significant ice packs, the island is not sighted again until 1808—the first landing does not take place until 1822.

1722

Yves Joseph de Kerguélen-Trémarec discovers the Îles Kerguélen.

1750

Antarctica receives its first literary treatment in *The Life and Adventures of Peter Wilkins, a Cornish Man: Relating Particularly his Shipwreck near the South Pole* by Robert Paltock.

1764

John Harrison's H-4 is adapted as the standard for the creation of longitude, which standardizes navigation based on measurement of time as it unfolds in increments. This leads to a revolution in how human beings measure the planet, and standardizes how space and time are measured.

1773

Captain James Cook and his crew become the first men to cross the Antarctic Circle.

1775

Captain Cook sails past South Georgia on his third Antarctic voyage, and discovers the South Sandwich Islands two weeks later.

1776–1779

On his final voyage of exploration, James Cook sails on the ships *Discovery* and *Resolution* along the west American coast and up to Bering Strait as far as 70°41'N with the hope of finding the Northwest Passage. There he encounters ice that stretches as far as he can see. It's an essential demonstration of the separation of the Asian and American continents. On his way home from this voyage, he died in Hawaii during a failed attempt to recover one of the *Discovery*'s boats that had been stolen by the natives.

1787

Ernst Chladni publishes *Entdeckungen über die Theorie des Klanges* (Discoveries in the Theory of Sound), which establishes sound as a series of waveform patterns. This helps create a new field of science, acoustics, or how sound travels through space.

1790

The sealing industry commences on South Georgia. Because the Europeans are involved in a continent-wide war, the sealers are primarily from New England.

1817

Mary Shelley writes *Frankenstein; or, The Modern Prometheus*, a story set in the Arctic that strikes the tone for the rise of several innovations in English literature for the next two centuries, and embeds a narrative of polar exploration at the heart of early Modernism.

1810

In search of new sealing grounds, Australian Frederick Hasselborough discovers Macquarie Island.

1819

Englishman William Smith discovers the South Shetland Islands, claims them for Great Britain.

1820

The Royal Navy sends Edward Bransfield, with William Smith as pilot, to search the waters southeast of the newly claimed South Shetlands. As a result, it is believed that he was the first person to see the Antarctic Peninsula.

JANUARY 27, 1820

Russian Fabian Gottlieb von Bellingshausen becomes the first person to see the Antarctic continent.

JANUARY, 1821

Fabian Gottlieb von Bellingshausen is the second explorer, after Cook, to complete a circumnavigation of Antarctica. In the process, he returns to the Antarctic waters and discovers the Alexander Islands and Peter I Island.

FEBRUARY, 1821

John Davis, an American sealer from Connecticut, arguably becomes the first person to land on the continent. Davis had been searching the South Shetlands for seals.

1821

Along with British sealer George Powell, Nathaniel Palmer discovers the South Orkney Islands.

1823

Englishman James Weddell sails to 74 degrees south. This is the farthest

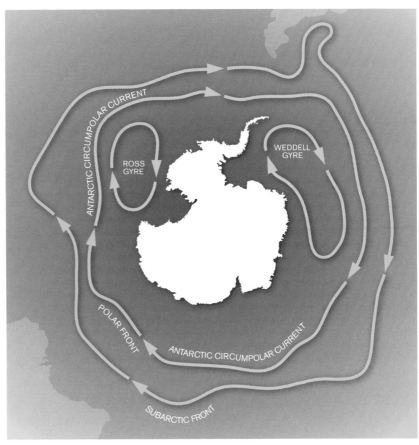

Ocean currents around Antarctica.

south yet reached and the sea bears his name to this day. No one is able to navigate this sea again for eighty years.

FEBRUARY, 1831

Englishman John Biscoe, an employee of the sealing business Enderby Brothers, discovers Enderby Land.

1839

Under the command of James Clark Ross, a British Naval expedition discovers the Antarctic mainland.

1840

Lieutenant Charles Wilkes, leader of the United States Exploring Expedition, sights an area that is given his name.

Jules-Sebastian Dumont d'Urville discovers a stretch of Antarctic coastline, which he names after his wife, Adélie. The species of penguin found in the same region was also named for his wife.

1841

Under the command of Sir James Clark Ross, two ships, *Erebus* and *Terror*, search for the South Magnetic Pole. Ross discovers Victoria Land and enters the sea, known today as the Ross Sea. He discovers Ross Island, Mt. Erebus, and the Ross Ice Shelf.

1882–1883

First International Polar Year.

1886–1909

Led by US Navy engineer Robert Peary, the Peary Arctic Club organizes eight expeditions to the Arctic. In one attempt, he crosses the Greenland ice cap, and from 1898–1902 makes his unsuccessful attempt to reach the North Pole. In 1908–1909, Peary reports that he has reached the North Pole with Matthew Henson and four indigenous people. His discovery is fiercely contested by Frederick A. Cook, another polar explorer, setting the tone for competitive explorations of remote

areas of the planet. There are still questions as to whether Peary reached the North Pole or exaggerated the distances he traveled. There was no navigator with him during the time when he claimed to have discovered the North Pole.

1892

Landing near the Antarctic Peninsula, Captain Carl Larsen, of the *Jason*, reports evidence of multiple geologic eras as seen in local fossils.

1895

A group of explorers led by Henryk Bull finds lichen on an offshore island near Cape Adare. This is the first sign of plant life in the region.

1898

Trapped in ice off the Antarctic Peninsula, Adrien de Gerlache and crew of the *Belgica* become the first to survive an Antarctic winter.

1899

Carsten Borchgrevink and crew of the *Southern Cross* land at Cape Adare and spend the winter on the continent, staying in huts they built.

1902

In February, Swedish geologist Otto Nordenskjöld and five crew members are left on Snow Hill Island where they spend two winters. Their ship *Antarctic* was crushed in the ice pack after leaving the crew on the island, creating two separate groups of explorers from the same group. Miraculously, the second crew was able to survive the winter and find their way back to Snow Hill Island where the whole party was rescued in 1903 by an Argentine relief ship.

Stuck in the ice for a year, German Erich von Drygalski and the crew of the *Gauss* discover Wilhelm II Land. The party does extensive scientific research, filling twenty volumes of reports.

1902

Robert F. Scott, Edward Wilson, and Ernest Shackleton strike out for the South Pole. Leaving McMurdo Sound bearing south across the Ross Ice Shelf, two months later they find themselves at 82° south suffering from snow blindness and scurvy, which forces them to return home.

1903–1905

Norwegian explorer Roald Amundsen completes the first successful navigation of the Northwest Passage. Thirty-four years will pass before the journey is made again.

MARCH, 1904

William S. Bruce and members of the Scottish National Antarctic Expedition aboard the *Scotia* discover Coats Land.

1904

Carl Larsen builds the region's first whaling station the station at Grytviken on South Georgia.

JANUARY, 1909

Douglas Mawson, Edgeworth David, and Alistair McKay reach the South Magnetic Pole.

1909–1912

Frederick A. Cook appears on the cover of the *New York Herald* as the discoverer of the geographic North Pole. In 1912, he makes the film *The Truth About the Pole*, a self-financed documentary of his exploits. His claims are later refuted and eventually discredited. His film is considered one of the first media spoofs of the twentieth century.

DECEMBER 14, 1911

Norwegian Roald Amundsen and four others reach the South Pole (90° S). Amundsen discovered a new route that took only fifty-seven days, bypassing most of the obstacles that had thwarted other expeditions.

JANUARY 18, 1912

Robert F. Scott, Edward Wilson, Edgar Evans, and Lawrence Oates reach the South Pole. Amundsen had already been there and planted a flag, deflating the British team's morale. Crushed by the fact that they had been beaten after a tortuous journey, the entire team perishes on the return trip.

1912

In December, Douglas Mawson begins his lone trek across George V Land back to his base at Commonwealth Bay. Mawson's two companions had died, but despite the tragedy, he makes it home. A new section of coast is discovered and radio is used for the first time in Antarctica to help with the rescue.

1914–1918

World War I limits non-military exploration of Antarctica.

OCTOBER, 1915

Ernest Shackleton's Imperial Trans-Antarctic Expedition prepares to cross the continent but cannot because his ship, the *Endurance*, is crushed in the ice of the Weddell Sea. Twenty-eight men camp on the floating ice for five more months before a break in the ice lets men take boats to Elephant Island in the South Shetlands. Three members of the team die, but the rest are eventually rescued in 1917.

1926

Soviet scientist Vladimir Vernadsky publishes his groundbreaking book *The Biosphere*, which call for humanity to reconsider how it relates to nature by hypothesizing that life is the geological force that shapes the Earth. He considers what he calls the noosphere, or human culture and cognition, to be the third stage of development of the planet after the geosphere (inanimate matter) and the biosphere (biological life).

1928

Hubert Wilkins flies from Deception Island in the South Shetlands in a Lockheed Vega monoplane, marking the first aerial exploration of the region.

1929

Douglas Mawson leads the British, Australian, and New Zealand Antarctic Research Expedition, which spends two summer seasons discovering Mac-Robertson Land and charting much of the coastline.

NOVEMBER 28, 1929

Richard E. Byrd and three others become the first people to fly over the South Pole, on a ten-hour flight from the Bay of Whales.

1932–1933

Second International Polar Year.

1936

Antarctica receives its first treatment in H.P. Lovecraft's "At The Mountains of Madness."

1938

The Third Reich sends out a team to do an Antarctic survey in an attempt to claim Queen Maud Land. Nazi flags and markers are dropped by airplane to demarcate German claims. These land claims are ignored after the war.

Richard Byrd's *Alone*, a book about the winter he spent in Antarctica by himself, becomes an international best seller.

1939–1945

World War II limits non-military exploration of Antarctica.

EARLY 1940S

The first permanent settlements and research bases are established in Antarctica.

1947

The US Navy organizes an Antarctic task force, comprising 4,700 men, thirteen ships, and twenty-three aircraft, deploying it to Antarctica for Operation Highjump, a survey mission. Under Rear Admiral Richard E. Byrd, a base is set up at Little America, extensive mapping of the coast and interior is accomplished, and over 70,000 aerial photographs are taken. Operation Highjump is followed by Operation Windmill.

British composer Ralph Vaughan Williams writes the first symphony dedicated to Antarctica. It serves as the score for the film *Scott of The Antarctic*, and is later developed into a symphony.

DECEMBER, 1947

From an aircraft, Finn Ronne, leader of a private American expedition based on Stonington Island, is the first to see the mountains of the western edge of the Filchner Ice Shelf.

1950

Sweden, Great Britain, and Norway launch a multinational expedition in Dronning Maud Land.

1957–1958

The Third International Geophysical Year (IGY) begins with Antarctica. The main effort of scientists from sixty-seven countries over the next eighteen months is to establish Antarctic exploration as a cooperative international effort, starting a process in which Antarctica becomes "non-national" and is preserved as a place for research, free of military presence.

1957

Vostok Station (USSR) is constructed.

DECEMBER, 1959

The twelve leading nations participating in the IGY sign the Antarctic Treaty in Washington, DC. The treaty is framed as an agreement marking an effort

TERRITORIAL CLAIMS ON ANTARCTICA
ACCORDING TO THE ANTARCTIC TREATY

Marion Island-*South Africa* ○

Iles Crozet-*France* ○

Bird Island-*UK* ○○ King Edward Point -*UK*

NORWAY

ARGENTINA

○ Orcadas-*Argentina*

Sanae IV-*South Africa* ○ ○ Maitri-*India*
Neumayer-*Germany* ○

Syowa-*Japan* ○ ○ Molodezhnaya-*Russia*

Iles Kerguelen-*France* ○

○ Esperanza-*Argentina/US* ○ Halley-*UK*
Bernardo O'Higgins-*Chile* ○

○ Mawson-*Australia*

Palmer-*US* ○ ○ Vernadsky-*Ukraine*
Rothera-*UK* ○ ○ San Martin-*Argentina*

○ Belgrano II-*Argentina*

BRITAIN

CHILE

AUSTRALIA

Zhongshan-*China* ○ ○ Davis-*Australia*

○ Amundsen-Scott-*US*

○ Vostok-*Russia*

○ Mirny-*Russia*

○ Casey-*Australia*

Scott-*NZ* ○○ McMurdo-*US*

○ Dumont D'Urville-*France*

NEW ZEALAND

FRANCE

○ Macquarie Island-*Australia*

to demilitarize the continent so that it "shall continue forever to be used exclusively for peaceful purposes." The treaty goes into effect in 1961 and guarantees access and scientific research in all territory south of 60° latitude.

MARCH 2, 1958

Forty years after Shackleton's expedition set out with the same goal, British geologist Sir Vivian Ernest Fuchs completes the first successful land crossing of Antarctica, traveling from the Weddell Sea to the Ross Sea and crossing the South Pole.

DECEMBER 7, 1972

The iconic "Blue Marble" photograph of Earth, shot from Apollo 17, is the first photograph of the planet that captures the south polar ice cap as well as Africa and the Arabian Peninsula.

1975

James Lovelock and Lynn Margulis postulate the Gaia Hypothesis, a concept that sees the Earth as a mass of intricately connected, interdependent systems.

1978

Emilio de Palma is the first person to be born in Antarctica, at an Argentine base.

1980

Scientists discover that the ozone layer in the stratosphere is being polluted.

1985

British scientists from Rothera and Halley bases report findings of a large hole in the ozone layer.

1996

Ice core samples taken from Vostok base show 420,000 years of the Earth's atmospheric history. The drilling also discovers Lake Vostok, Antarctica's largest underground freshwater lake. Sealed for over twenty-five million years under four kilometers of ice, Lake Vostok is larger that Lake Ontario.

1997

Towing a 400-pound sled and using skis and a sail, Norwegian Boerge Ousland becomes the first person to cross Antarctica unsupported. The journey takes sixty-four days, from Berkner Island to Scott base.

1997

Kyoto Protocol is negotiated, with the aim of reducing greenhouse gases.

1998

Antarctic Treaty Protocol of Environmental Protection is now enforced.

MARCH, 2000

Iceberg B-15, the largest recorded iceberg, calves off the Ross Ice Sea shelf. With an area of over 11,000 km², it is larger than Jamaica.

2001

Thousands of Antarctic penguins are reported dead or dying due to B-15 cutting them off from their food supply.

2005

The European Project for Ice Coring in Antarctica reports that carbon dioxide in the current atmosphere is greater than at any time during the last 650,000 years.

2006

NASA research reveals that shrinkage of the Antarctic ice sheet over the last three years has raised global sea levels by 1.2 millimeters.

2007

The South Pole Telescope (SPT) opens to search for signs of dark energy in the universe.

Unveiled by the Belgian-based International Polar Foundation, the world's first zero-emissions polar science station is constructed in Antarctica to conduct research on climate change.

MARCH 2007–MARCH 2009

The Fourth International Polar Year spans two years in order for researchers to get the opportunity to work in both polar regions or work summer and winter.

DECEMBER 2007–JANUARY 2008

Paul D. Miller travels to Antarctica aboard the Russian vessel *Akademik Ioeffe*, a decommissioned naval ship that specializes in hydro-acoustic research. He writes *Terra Nova*, a digital media symphony about Antarctica, while onboard the ship.

JANUARY 16, 2010

The largest wind farm in Antarctica opens. It can generate enough electricity to power over 500 homes, and is formally turned on in a joint New Zealand-US project on the Ross Sea coast.

2010

Paul D. Miller goes to the High Arctic Circle with the Cape Farewell Project to complete a series of compositions entitled *Arctic Rhythms: Ice Music*.

POSTERS AND STICKERS

Alex Steinweiss is widely credited as coming up with the idea of putting images on record sleeves. Since 1938, graphic design has always been a part of how people respond to music. The graphic design prints in this section respond to the idea of a fictional revolution in Antarctica.

Artist and designer Aleksandr Rodchenko wrote: "In order to educate man to a new longing, everyday familiar objects must be shown to him with totally unexpected perspectives and in unexpected situations. New objects should be depicted from different sides in order to provide a complete impression of the object." That's the paradox of stickers and posters—they are visual sound bites of the urban landscape. I wanted to show what it would be like to create a print campaign for a place that most people have never visited.

MANIFESTO FOR A PEOPLE'S REPUBLIC OF ANTARCTICA

MANIFESTO FOR A PEOPLE'S

ANTARCTIC MINISTRY OF INFORMATION

FRIGIDUS OBSCURUM

FRIGIDUS OBSCURUM

REPUBLIC OF ANTARCTICA

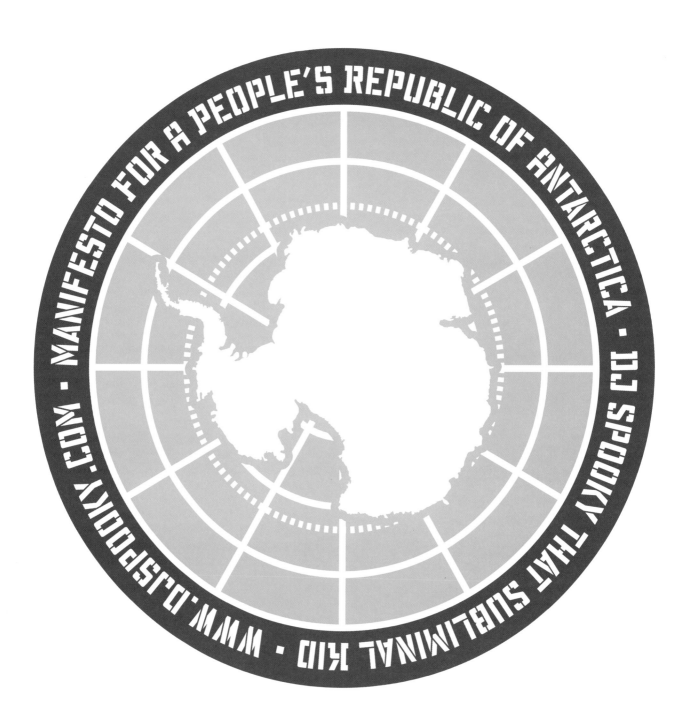

MANIFESTO FOR A PEOPLE'S REPUBLIC OF ANTARCTICA · DJ SPOOKY THAT SUBLIMINAL KID · WWW.DJSPOOKY.COM · MANIFESTO FOR A PEOPLE'S REPUBLIC OF ANTARCTICA · DJ SPOOKY THAT SUBLIMINAL KID · WWW.DJSPOOKY.COM

DJ SPOOKY PRESENTS

TERRANOVA
SINFONIA ANTARCTICA

MANIFESTO

FOR A PEOPLE'S REPUBLIC OF
ANTARCTICA

MANIFESTO FOR A PEOPLE'S REPUBLIC OF ANTARCTICA

ANTARCTIC MINISTRY OF INFORMATION
FRIGIDUS OBSCURUM

MANIFESTO FOR A

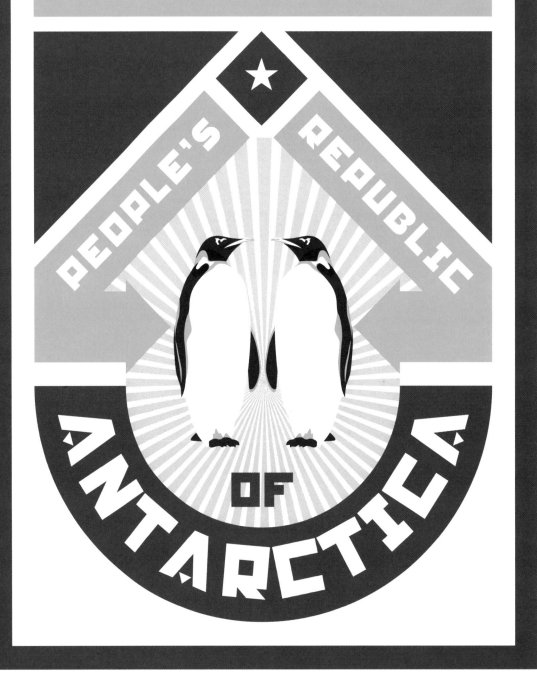

PEOPLE'S REPUBLIC OF ANTARCTICA

MANIFESTO

FOR A PEOPLE'S REPUBLIC OF ANTARCTICA

MANIFESTO

إنتاركتيكا

FOR A PEOPLE'S REPUBLIC OF
ANTARCTICA

MANIFESTO

南极洲

FOR A PEOPLE'S REPUBLIC OF

ANTARCTICA

MANIFESTO

אנטארקטיקה

FOR A PEOPLE'S REPUBLIC OF
ANTARCTICA

MANIFESTO FOR A PEOPLE'S REPUBLIC OF ANTARCTICA · DJ SPOOKY THAT SUBLIMINAL KID · WWW.DJSPOOKY.COM ·

FRIGIDUS OBSCURUM

MANIFESTO FOR A PEOPLE'S REPUBLIC OF ANTARCTICA · DJ SPOOKY THAT SUBLIMINAL KID · WWW.DJSPOOKY.COM ·

PEOPLE'S REPUBLIC OF ANTARCTICA · DJ SPOOKY THAT SUBLIMINAL KID · WWW

MANIFESTO FOR A PEOPLE'S REPUBLIC OF ANTARCTICA · DJ SPOOKY THAT SUBLIMINAL KID · WWW.DJSPOOKY.COM · MANIFESTO FOR A

MANIFESTO

अंटार्कटिका

FOR A PEOPLE'S REPUBLIC OF ANTARCTICA

MANIFESTO

MANIFESTO FOR A PEOPLE'S REPUBLIC OF ANTARCTICA · DJ SPOOKY THAT SUBLIMINAL KID · WWW.DJSPOOKY.COM · MANIFESTO FOR A PEOPLE'S REPUBLIC OF ANTARCTICA · DJ SPOOKY THAT SUBLIMINAL KID · WWW.DJSPOOKY.COM ·

南極

FOR A PEOPLE'S REPUBLIC OF
ANTARCTICA

DJ SPOOKY PRESENTS

TERRANOVA
SINFONIA ANTARCTICA

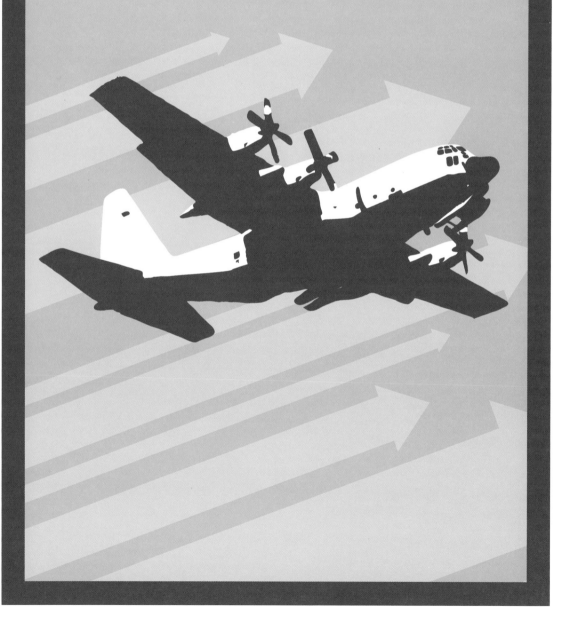

MANIFESTO

남극대륙

FOR A PEOPLE'S REPUBLIC OF
ANTARCTICA

THE ANTARCTIC TREATY (23 JUNE 1961). [PREAMBLE] THE GOVERNMENTS OF ARGENTINA, AUSTRALIA, BELGIUM, CHILE, THE FRENCH REPUBLIC, JAPAN, NEW ZEALAND, NORWAY, THE UNION OF SOUTH AFRICA, THE UNION OF SOVIET SOCIALIST REPUBLICS, THE UNITED KINGDOM OF GREAT BRITAIN AND NORTHERN IRELAND, AND THE UNITED STATES OF AMERICA, RECOGNIZING THAT IT IS IN THE INTEREST OF ALL MANKIND THAT ANTARCTICA SHALL CONTINUE FOREVER TO BE USED EXCLUSIVELY FOR PEACEFUL PURPOSES AND SHALL NOT BECOME THE SCENE OR OBJECT OF INTERNATIONAL DISCORD; ACKNOWLEDGING THE SUBSTANTIAL CONTRIBUTIONS TO SCIENTIFIC KNOWLEDGE RESULTING FROM INTERNATIONAL COOPERATION IN SCIENTIFIC INVESTIGATION IN ANTARCTICA; CONVINCED THAT THE ESTABLISHMENT OF A FIRM FOUNDATION FOR THE CONTINUATION AND DEVELOPMENT OF SUCH COOPERATION ON THE BASIS OF FREEDOM OF SCIENTIFIC INVESTIGATION IN ANTARCTICA AS APPLIED DURING THE INTERNATIONAL GEOPHYSICAL YEAR ACCORDS WITH THE INTERESTS OF SCIENCE AND THE PROGRESS OF ALL MANKIND; CONVINCED ALSO THAT A TREATY ENSURING THE USE OF ANTARCTICA FOR PEACEFUL PURPOSES ONLY AND THE CONTINUANCE OF INTERNATIONAL HARMONY IN ANTARCTICA WILL FURTHER THE PURPOSES AND PRINCIPLES EMBODIED IN THE CHARTER OF THE UNITED NATIONS; HAVE AGREED AS FOLLOWS: ARTICLE I [ANTARCTICA FOR PEACEFUL PURPOSES ONLY] I. ANTARCTICA SHALL BE USED FOR PEACEFUL PURPOSES ONLY. THERE SHALL BE PROHIBITED, INTER ALIA, ANY MEASURES OF A MILITARY NATURE, SUCH AS THE ESTABLISHMENT OF MILITARY BASES AND FORTIFICATIONS, THE CARRYING OUT OF MILITARY MANEUVERS, AS WELL AS THE TESTING OF ANY TYPE OF WEAPONS. 2. THE PRESENT TREATY SHALL NOT PREVENT THE USE OF MILITARY PERSONNEL OR EQUIPMENT FOR SCIENTIFIC RESEARCH OR FOR ANY OTHER PEACEFUL PURPOSE. ARTICLE II [FREEDOM OF SCIENTIFIC INVESTIGATION TO CONTINUE] FREEDOM OF SCIENTIFIC INVESTIGATION IN ANTARCTICA AND COOPERATION TOWARD THAT END, AS APPLIED DURING THE INTERNATIONAL GEOPHYSICAL YEAR, SHALL CONTINUE, SUBJECT TO THE PROVISIONS OF THE PRESENT TREATY. ARTICLE III [PLANS AND RESULTS FREELY AVAILABLE] I. IN ORDER TO PROMOTE INTERNATIONAL COOPERATION IN SCIENTIFIC INVESTIGATION IN ANTARCTICA, AS PROVIDED FOR IN ARTICLE II OF THE PRESENT TREATY, THE CONTRACTING PARTIES AGREE THAT, TO THE GREATEST EXTENT FEASIBLE AND PRACTICABLE: (A) INFORMATION REGARDING PLANS FOR SCIENTIFIC PROGRAMS IN ANTARCTICA SHALL BE EXCHANGED TO PERMIT MAXIMUM ECONOMY AND EFFICIENCY OF OPERATIONS; (B) SCIENTIFIC PERSONNEL SHALL BE EXCHANGED IN ANTARCTICA BETWEEN EXPEDITIONS AND STATIONS; (C) SCIENTIFIC OBSERVATIONS AND RESULTS FROM ANTARCTICA SHALL BE EXCHANGED AND MADE FREELY AVAILABLE. 2. IN IMPLEMENTING THIS ARTICLE, EVERY ENCOURAGEMENT SHALL BE GIVEN TO THE ESTABLISHMENT OF COOPERATIVE WORKING RELATIONS WITH THOSE SPECIALIZED AGENCIES OF THE UNITED NATIONS AND OTHER INTERNATIONAL ORGANIZATIONS HAVING A SCIENTIFIC OR TECHNICAL INTEREST IN ANTARCTICA. ARTICLE IV [TERRITORIAL CLAIMS] I. NOTHING CONTAINED IN THE PRESENT TREATY SHALL BE INTERPRETED AS: (A) A RENUNCIATION BY ANY CONTRACTING PARTY OF PREVIOUSLY ASSERTED RIGHTS OF OR CLAIMS TO TERRITORIAL SOVEREIGNTY IN ANTARCTICA; (B) A RENUNCIATION OR DIMINUTION BY ANY CONTRACTING PARTY OF ANY BASIS OF CLAIM TO TERRITORIAL SOVEREIGNTY IN ANTARCTICA WHICH IT MAY HAVE WHETHER AS A RESULT OF ITS ACTIVITIES OR THOSE OF ITS NATIONALS IN ANTARCTICA, OR OTHERWISE; (C) PREJUDICING THE POSITION OF ANY CONTRACTING PARTY AS REGARDS ITS RECOGNITION OR NON-RECOGNITION OF ANY OTHER STATE'S RIGHT OF OR CLAIM OR BASIS OF CLAIM TO TERRITORIAL SOVEREIGNTY IN ANTARCTICA. 2. NO ACTS OR ACTIVITIES TAKING PLACE WHILE THE PRESENT TREATY IS IN FORCE SHALL CONSTITUTE A BASIS FOR ASSERTING, SUPPORTING OR DENYING A CLAIM TO TERRITORIAL SOVEREIGNTY IN ANTARCTICA OR CREATE ANY RIGHTS OF SOVEREIGNTY IN ANTARCTICA. NO NEW CLAIM, OR ENLARGEMENT OF AN EXISTING CLAIM, TO TERRITORIAL SOVEREIGNTY SHALL BE ASSERTED WHILE THE PRESENT TREATY IS IN FORCE. ARTICLE V [NUCLEAR EXPLOSIONS PROHIBITED] I. ANY NUCLEAR EXPLOSIONS IN ANTARCTICA AND THE DISPOSAL THERE OF RADIOACTIVE WASTE MATERIAL SHALL BE PROHIBITED. 2. IN THE EVENT OF THE CONCLUSION OF INTERNATIONAL AGREEMENTS CONCERNING THE USE OF NUCLEAR ENERGY, INCLUDING NUCLEAR EXPLOSIONS AND THE DISPOSAL OF RADIOACTIVE WASTE MATERIAL, TO WHICH ALL OF THE CONTRACTING PARTIES WHOSE REPRESENTATIVES ARE ENTITLED TO PARTICIPATE IN THE MEETINGS PROVIDED FOR UNDER ARTICLE IX ARE PARTIES, THE RULES ESTABLISHED UNDER SUCH AGREEMENTS SHALL APPLY IN ANTARCTICA. ARTICLE VI [AREA COVERED BY TREATY] THE PROVISIONS OF THE PRESENT TREATY SHALL APPLY TO THE AREA SOUTH OF 60° SOUTH LATITUDE, INCLUDING ALL ICE SHELVES, BUT NOTHING IN THE PRESENT TREATY SHALL PREJUDICE OR IN ANY WAY AFFECT THE RIGHTS, OR THE EXERCISE OF THE RIGHTS, OF ANY STATE UNDER INTERNATIONAL LAW WITH REGARD TO THE HIGH SEAS WITHIN THAT AREA. ARTICLE VII [FREE ACCESS FOR UNDER PROVIDED INSPECTION] I. IN ORDER TO PROMOTE THE OBJECTIVES AND ENSURE THE OBSERVANCE OF THE PROVISIONS OF THE PRESENT TREATY, EACH CONTRACTING PARTY WHOSE REPRESENTATIVES ARE ENTITLED TO PARTICIPATE IN THE MEETINGS REFERRED TO IN ARTICLE IX OF THE TREATY SHALL HAVE THE RIGHT TO DESIGNATE OBSERVERS TO CARRY OUT ANY INSPECTION PROVIDED FOR BY THE PRESENT ARTICLE. OBSERVERS SHALL BE NATIONALS OF THE CONTRACTING PARTIES WHICH DESIGNATE THEM. THE NAMES OF THE OBSERVERS SHALL BE COMMUNICATED TO EVERY OTHER CONTRACTING PARTY HAVING THE RIGHT TO DESIGNATE OBSERVERS, AND LIKE NOTICE SHALL BE GIVEN OF THE TERMINATION OF THEIR APPOINTMENT. 2. EACH OBSERVER DESIGNATED IN ACCORDANCE WITH THE PROVISIONS OF PARAGRAPH I OF THIS ARTICLE SHALL HAVE COMPLETE FREEDOM OF ACCESS AT ANY TIME TO ANY OR ALL AREAS OF ANTARCTICA. 3. ALL AREAS OF ANTARCTICA, INCLUDING ALL STATIONS, INSTALLATIONS AND EQUIPMENT WITHIN THOSE AREAS, AND ALL SHIPS AND AIRCRAFT AT POINTS OF DISCHARGING OR EMBARKING CARGOES OR PERSONNEL IN ANTARCTICA, SHALL BE OPEN AT ALL TIMES TO INSPECTION BY ANY OBSERVERS DESIGNATED IN ACCORDANCE WITH PARAGRAPH I OF THIS ARTICLE. 4. AERIAL OBSERVATION MAY BE CARRIED OUT AT ANY TIME OVER ANY OR ALL AREAS OF ANTARCTICA BY ANY OF THE CONTRACTING PARTIES HAVING THE RIGHT TO DESIGNATE OBSERVERS. 5. EACH CONTRACTING PARTY SHALL, AT THE TIME WHEN THE PRESENT TREATY ENTERS INTO FORCE FOR IT, INFORM THE OTHER CONTRACTING PARTIES, AND THEREAFTER SHALL GIVE NOTICE IN ADVANCE, OF (A) ALL EXPEDITIONS TO AND WITHIN ANTARCTICA, ON THE PART OF ITS SHIPS OR NATIONALS, AND ALL EXPEDITIONS TO ANTARCTICA ORGANIZED IN OR PROCEEDING FROM ITS TERRITORY; (B) ALL STATIONS IN ANTARCTICA OCCUPIED BY ITS NATIONALS; AND (C) ANY MILITARY PERSONNEL OR EQUIPMENT INTENDED TO BE INTRODUCED BY IT INTO ANTARCTICA SUBJECT TO THE CONDITIONS PRESCRIBED IN PARAGRAPH 2 OF ARTICLE I OF THE PRESENT TREATY. ARTICLE VIII [PERSONNEL UNDER JURISDICTION OF THEIR OWN STATES] I. IN ORDER TO FACILITATE THE EXERCISE OF THEIR FUNCTIONS UNDER THE PRESENT TREATY, AND WITHOUT PREJUDICE TO THE RESPECTIVE POSITIONS OF THE CONTRACTING PARTIES RELATING TO JURISDICTION OVER ALL OTHER PERSONS IN ANTARCTICA, OBSERVERS DESIGNATED UNDER PARAGRAPH I OF ARTICLE VII AND SCIENTIFIC PERSONNEL EXCHANGED UNDER SUBPARAGRAPH I(B) OF ARTICLE III OF THE TREATY, AND MEMBERS OF THE STAFFS ACCOMPANYING ANY SUCH PERSONS, SHALL BE SUBJECT ONLY TO THE JURISDICTION OF THE CONTRACTING PARTY OF WHICH THEY ARE NATIONALS IN RESPECT OF ALL ACTS OR OMISSIONS OCCURRING WHILE THEY ARE IN ANTARCTICA FOR THE PURPOSE OF EXERCISING THEIR FUNCTIONS. 2. WITHOUT PREJUDICE TO THE PROVISIONS OF PARAGRAPH I OF THIS ARTICLE, AND PENDING THE ADOPTION OF MEASURES IN PURSUANCE OF SUBPARAGRAPH I(E) OF ARTICLE IX, THE CONTRACTING PARTIES CONCERNED IN ANY CASE OF DISPUTE WITH REGARD TO THE EXERCISE OF JURISDICTION IN ANTARCTICA SHALL IMMEDIATELY CONSULT TOGETHER WITH A VIEW TO REACHING A MUTUALLY ACCEPTABLE SOLUTION. ARTICLE IX [TREATY STATES TO MEET PERIODICALLY] I. REPRESENTATIVES OF THE CONTRACTING PARTIES NAMED IN THE PREAMBLE TO THE PRESENT TREATY SHALL MEET AT THE CITY OF CANBERRA WITHIN TWO MONTHS AFTER DATE OF ENTRY INTO FORCE OF THE TREATY, AND THEREAFTER AT SUITABLE INTERVALS AND PLACES, FOR THE PURPOSE OF EXCHANGING INFORMATION, CONSULTING TOGETHER ON MATTERS OF COMMON INTEREST PERTAINING TO ANTARCTICA, AND FORMULATING AND CONSIDERING, AND RECOMMENDING TO THEIR GOVERNMENTS, MEASURES IN FURTHERANCE OF THE PRINCIPLES AND OBJECTIVES OF THE TREATY, INCLUDING MEASURES REGARDING: (A) USE OF ANTARCTICA FOR PEACEFUL PURPOSES ONLY; (B) FACILITATION OF SCIENTIFIC RESEARCH IN ANTARCTICA; (C) FACILITATION OF INTERNATIONAL SCIENTIFIC COOPERATION IN ANTARCTICA; (D) FACILITATION OF THE EXERCISE OF THE RIGHTS OF INSPECTION PROVIDED FOR IN ARTICLE VII OF THE TREATY; (E) QUESTIONS RELATING TO THE EXERCISE OF JURISDICTION IN ANTARCTICA; (F) PRESERVATION AND CONSERVATION OF LIVING RESOURCES IN ANTARCTICA. 2. EACH CONTRACTING PARTY WHICH HAS BECOME A PARTY TO THE PRESENT TREATY BY ACCESSION UNDER ARTICLE XIII SHALL BE ENTITLED TO APPOINT REPRESENTATIVES TO PARTICIPATE IN THE MEETINGS REFERRED TO IN PARAGRAPH I OF THE PRESENT ARTICLE, DURING SUCH TIME AS THAT CONTRACTING PARTY DEMONSTRATES ITS INTEREST IN ANTARCTICA BY CONDUCTING SUBSTANTIAL SCIENTIFIC RESEARCH ACTIVITY THERE, SUCH AS THE ESTABLISHMENT OF A SCIENTIFIC STATION OR THE DESPATCH OF A SCIENTIFIC EXPEDITION. 3. REPORTS FROM THE OBSERVERS REFERRED TO IN ARTICLE VII OF THE PRESENT TREATY SHALL BE TRANSMITTED TO THE REPRESENTATIVES OF THE CONTRACTING PARTIES WHO PARTICIPATE IN THE MEETINGS REFERRED TO IN PARAGRAPH I OF THE PRESENT ARTICLE. 4. THE MEASURES REFERRED TO IN PARAGRAPH I OF THIS ARTICLE SHALL BECOME EFFECTIVE WHEN APPROVED BY ALL THE CONTRACTING PARTIES WHOSE REPRESENTATIVES WERE ENTITLED TO PARTICIPATE IN THE MEETINGS HELD TO CONSIDER THOSE MEASURES. 5. ANY OR ALL OF THE RIGHTS ESTABLISHED IN THE PRESENT TREATY MAY BE EXERCISED AS FROM THE DATE OF ENTRY INTO FORCE OF THE TREATY WHETHER OR NOT ANY MEASURES FACILITATING THE EXERCISE OF SUCH RIGHTS HAVE BEEN PROPOSED, CONSIDERED OR APPROVED AS PROVIDED IN THIS ARTICLE. ARTICLE X [DISCOURAGES ACTIVITIES CONTRARY TO TREATY] EACH OF THE CONTRACTING PARTIES UNDERTAKES TO EXERT APPROPRIATE EFFORTS, CONSISTENT WITH THE CHARTER OF THE UNITED NATIONS, TO THE END THAT NO ONE ENGAGES IN ANY ACTIVITY IN ANTARCTICA CONTRARY TO THE PRINCIPLES OR PURPOSES OF THE PRESENT TREATY. ARTICLE XI [SETTLEMENT OF DISPUTES] I. IF ANY DISPUTE ARISES BETWEEN TWO OR MORE OF THE CONTRACTING PARTIES CONCERNING THE INTERPRETATION OR APPLICATION OF THE PRESENT TREATY, THOSE CONTRACTING PARTIES SHALL CONSULT AMONG THEMSELVES WITH A VIEW TO HAVING THE DISPUTE RESOLVED BY NEGOTIATION, INQUIRY, MEDIATION, CONCILIATION, ARBITRATION, JUDICIAL SETTLEMENT OR OTHER PEACEFUL MEANS OF THEIR OWN CHOICE. 2. ANY DISPUTE OF THIS CHARACTER NOT SO RESOLVED SHALL, WITH THE CONSENT, IN EACH CASE, OF ALL PARTIES TO THE DISPUTE, BE REFERRED TO THE INTERNATIONAL COURT OF JUSTICE FOR SETTLEMENT; BUT FAILURE TO REACH AGREEMENT ON REFERENCE TO THE INTERNATIONAL COURT SHALL NOT ABSOLVE PARTIES TO THE DISPUTE FROM THE RESPONSIBILITY OF CONTINUING TO SEEK TO RESOLVE IT BY ANY OF THE VARIOUS PEACEFUL MEANS REFERRED TO IN PARAGRAPH I OF THIS ARTICLE. ARTICLE XII [MODIFICATION, REVIEW AFTER 30 YEARS] I. (A) THE PRESENT TREATY MAY BE MODIFIED OR AMENDED AT ANY TIME BY UNANIMOUS AGREEMENT OF THE CONTRACTING PARTIES WHOSE REPRESENTATIVES ARE ENTITLED TO PARTICIPATE IN THE MEETINGS PROVIDED FOR UNDER ARTICLE IX. ANY SUCH MODIFICATION OR AMENDMENT SHALL ENTER INTO FORCE WHEN THE DEPOSITARY GOVERNMENT HAS RECEIVED NOTICE FROM ALL SUCH CONTRACTING PARTIES THAT THEY HAVE RATIFIED IT. (B) SUCH MODIFICATION OR AMENDMENT SHALL THEREAFTER ENTER INTO FORCE AS TO ANY OTHER CONTRACTING PARTY WHEN NOTICE OF RATIFICATION BY IT HAS BEEN RECEIVED BY THE DEPOSITARY GOVERNMENT. ANY SUCH CONTRACTING PARTY FROM WHICH NO NOTICE OF RATIFICATION IS RECEIVED WITHIN A PERIOD OF TWO YEARS FROM THE DATE OF ENTRY INTO FORCE OF THE MODIFICATION OR AMENDMENT IN ACCORDANCE WITH THE PROVISIONS OF SUBPARAGRAPH I(A) OF THIS ARTICLE SHALL BE DEEMED TO HAVE WITHDRAWN FROM THE PRESENT TREATY ON THE DATE OF THE EXPIRATION OF SUCH PERIOD. 2. (A) IF AFTER THE EXPIRATION OF THIRTY YEARS FROM THE DATE OF ENTRY INTO FORCE OF THE PRESENT TREATY, ANY OF THE CONTRACTING PARTIES WHOSE REPRESENTATIVES ARE ENTITLED TO PARTICIPATE IN THE MEETINGS PROVIDED FOR UNDER ARTICLE IX SO REQUESTS BY A COMMUNICATION ADDRESSED TO THE DEPOSITARY GOVERNMENT, A CONFERENCE OF ALL THE CONTRACTING PARTIES SHALL BE HELD AS SOON AS PRACTICABLE TO REVIEW THE OPERATION OF THE TREATY. (B) ANY MODIFICATION OR AMENDMENT TO THE PRESENT TREATY WHICH IS APPROVED AT SUCH A CONFERENCE BY A MAJORITY OF THE CONTRACTING PARTIES THERE REPRESENTED, INCLUDING A MAJORITY OF THOSE WHOSE REPRESENTATIVES ARE ENTITLED TO PARTICIPATE IN THE MEETINGS PROVIDED FOR UNDER ARTICLE IX, SHALL BE COMMUNICATED BY THE DEPOSITARY GOVERNMENT TO ALL THE CONTRACTING PARTIES IMMEDIATELY AFTER THE TERMINATION OF THE CONFERENCE AND SHALL ENTER INTO FORCE IN ACCORDANCE WITH THE PROVISIONS OF PARAGRAPH I OF THE PRESENT ARTICLE. (C) IF ANY SUCH MODIFICATION OR AMENDMENT HAS NOT ENTERED INTO FORCE IN ACCORDANCE WITH THE PROVISIONS OF SUBPARAGRAPH I(A) OF THIS ARTICLE WITHIN A PERIOD OF TWO YEARS AFTER THE DATE OF ITS COMMUNICATION TO ALL THE CONTRACTING PARTIES, ANY CONTRACTING PARTY MAY AT ANY TIME AFTER THE EXPIRATION OF THAT PERIOD GIVE NOTICE TO THE DEPOSITARY GOVERNMENT OF ITS WITHDRAWAL FROM THE PRESENT TREATY; AND SUCH WITHDRAWAL SHALL TAKE EFFECT TWO YEARS AFTER THE RECEIPT OF THE NOTICE BY THE DEPOSITARY GOVERNMENT. ARTICLE XIII [SIGNATURE AND RATIFICATION] I. THE PRESENT TREATY SHALL BE SUBJECT TO RATIFICATION BY THE SIGNATORY STATES. IT SHALL BE OPEN FOR ACCESSION BY ANY STATE WHICH IS A MEMBER OF THE UNITED NATIONS, OR BY ANY OTHER STATE WHICH MAY BE INVITED TO ACCEDE TO THE TREATY WITH THE CONSENT OF ALL THE CONTRACTING PARTIES WHOSE REPRESENTATIVES ARE ENTITLED TO PARTICIPATE IN THE MEETINGS PROVIDED FOR UNDER ARTICLE IX OF THE TREATY. 2. RATIFICATION OF OR ACCESSION TO THE PRESENT TREATY SHALL BE EFFECTED BY EACH STATE IN ACCORDANCE WITH ITS CONSTITUTIONAL PROCESSES. 3. INSTRUMENTS OF RATIFICATION AND INSTRUMENTS OF ACCESSION SHALL BE DEPOSITED WITH THE GOVERNMENT OF THE UNITED STATES OF AMERICA, HEREBY DESIGNATED AS THE DEPOSITARY GOVERNMENT. 4. THE DEPOSITARY GOVERNMENT SHALL INFORM ALL SIGNATORY AND ACCEDING STATES OF THE DATE OF EACH DEPOSIT OF AN INSTRUMENT OF RATIFICATION OR ACCESSION, AND THE DATE OF ENTRY INTO FORCE OF THE TREATY AND OF ANY MODIFICATION OR AMENDMENT THERETO. 5. UPON THE DEPOSIT OF INSTRUMENTS OF RATIFICATION BY ALL THE SIGNATORY STATES, THE PRESENT TREATY SHALL ENTER INTO FORCE FOR THOSE STATES AND FOR STATES WHICH HAVE DEPOSITED INSTRUMENTS OF ACCESSION. THEREAFTER THE TREATY SHALL ENTER INTO FORCE FOR ANY ACCEDING STATE UPON THE DEPOSIT OF ITS INSTRUMENT OF ACCESSION. 6. THE PRESENT TREATY SHALL BE REGISTERED BY THE DEPOSITARY GOVERNMENT PURSUANT TO ARTICLE 102 OF THE CHARTER OF THE UNITED NATIONS. ARTICLE XIV [UNITED STATES IS REPOSITORY] THE PRESENT TREATY, DONE IN THE ENGLISH, FRENCH, RUSSIAN AND SPANISH LANGUAGES, EACH VERSION BEING EQUALLY AUTHENTIC, SHALL BE DEPOSITED IN THE ARCHIVES OF THE GOVERNMENT OF THE UNITED STATES OF AMERICA, WHICH SHALL TRANSMIT DULY CERTIFIED COPIES THEREOF TO THE GOVERNMENTS OF THE SIGNATORY AND ACCEDING STATES. IN WITNESS WHEREOF, THE UNDERSIGNED PLENIPOTENTIARIES, DULY AUTHORIZED, HAVE SIGNED THE PRESENT TREATY. DONE AT WASHINGTON THIS FIRST DAY OF DECEMBER, ONE THOUSAND NINE HUNDRED AND FIFTY-NINE. FOR ARGENTINA: ADOLFO SCILINGO ALBERTO A. CASELLA FOR AUSTRALIA: HOWARD BEALE FOR BELGIUM: OBERT DE THIEUSIES FOR CHILE: MARCIAL MORA M. E. GAJARDO V. JULIO ESCUDERO FOR THE FRENCH REPUBLIC: PIERRE CHARPENTIER FOR JAPAN: KOICHIRO ASAKAI T. SHIMODA FOR NEW ZEALAND: G. D. L. WHITE FOR NORWAY: PAUL KOHT FOR THE UNION OF SOUTH AFRICA: WENTZEL C. DU PLESSIS FOR THE UNION OF SOVIET SOCIALIST REPUBLICS: V. KUZNETSOV FOR THE UNITED KINGDOM OF GREAT BRITAIN AND NORTHERN IRELAND: HAROLD CACCIA FOR THE UNITED STATES OF AMERICA: HERMAN PHLEGER PAUL C. DANIELS

THE ANTARCTIC TREATY (23 JUNE 1961). [PREAMBLE] THE GOVERNMENTS OF ARGENTINA, AUSTRALIA, BELGIUM, CHILE, THE FRENCH REPUBLIC, JAPAN, NEW ZEALAND, NORWAY, THE UNION OF SOUTH AFRICA, THE UNION OF SOVIET SOCIALIST REPUBLICS, THE UNITED KINGDOM OF GREAT BRITAIN AND NORTHERN IRELAND, AND THE UNITED STATES OF AMERICA, RECOGNIZING THAT IT IS IN THE INTEREST OF ALL MANKIND THAT ANTARCTICA SHALL CONTINUE FOREVER TO BE USED EXCLUSIVELY FOR PEACEFUL PURPOSES AND SHALL NOT BECOME THE SCENE OR OBJECT OF INTERNATIONAL DISCORD; ACKNOWLEDGING THE SUBSTANTIAL CONTRIBUTIONS TO SCIENTIFIC KNOWLEDGE RESULTING FROM INTERNATIONAL COOPERATION IN SCIENTIFIC INVESTIGATION IN ANTARCTICA; CONVINCED THAT THE ESTABLISHMENT OF A FIRM FOUNDATION FOR THE CONTINUATION AND DEVELOPMENT OF SUCH COOPERATION ON THE BASIS OF FREEDOM OF SCIENTIFIC INVESTIGATION IN ANTARCTICA AS APPLIED DURING THE INTERNATIONAL GEOPHYSICAL YEAR ACCORDS WITH THE INTERESTS OF SCIENCE AND THE PROGRESS OF ALL MANKIND; CONVINCED ALSO THAT A TREATY ENSURING THE USE OF ANTARCTICA FOR PEACEFUL PURPOSES ONLY AND THE CONTINUANCE OF INTERNATIONAL HARMONY IN ANTARCTICA WILL FURTHER THE PURPOSES AND PRINCIPLES EMBODIED IN THE CHARTER OF THE UNITED NATIONS; HAVE AGREED AS FOLLOWS: ARTICLE I [ANTARCTICA FOR PEACEFUL PURPOSES ONLY] 1. ANTARCTICA SHALL BE USED FOR PEACEFUL PURPOSES ONLY. THERE SHALL BE PROHIBITED, INTER ALIA, ANY MEASURES OF A MILITARY NATURE, SUCH AS THE ESTABLISHMENT OF MILITARY BASES AND FORTIFICATIONS, THE CARRYING OUT OF MILITARY MANEUVERS, AS WELL AS THE TESTING OF ANY TYPE OF WEAPONS. 2. THE PRESENT TREATY SHALL NOT PREVENT THE USE OF MILITARY PERSONNEL OR EQUIPMENT FOR SCIENTIFIC RESEARCH OR FOR ANY OTHER PEACEFUL PURPOSES. ARTICLE II [FREEDOM OF SCIENTIFIC INVESTIGATION TO CONTINUE] FREEDOM OF SCIENTIFIC INVESTIGATION IN ANTARCTICA AND COOPERATION TOWARD THAT END, AS APPLIED DURING THE INTERNATIONAL GEOPHYSICAL YEAR, SHALL CONTINUE, SUBJECT TO THE PROVISIONS OF THE PRESENT TREATY. ARTICLE III 1. IN ORDER TO PROMOTE INTERNATIONAL COOPERATION IN SCIENTIFIC INVESTIGATION IN ANTARCTICA, AS PROVIDED FOR IN ARTICLE II OF THE PRESENT TREATY, THE CONTRACTING PARTIES AGREE THAT, TO THE GREATEST EXTENT FEASIBLE AND PRACTICABLE: (A) INFORMATION REGARDING PLANS FOR SCIENTIFIC PROGRAMS IN ANTARCTICA SHALL BE EXCHANGED TO PERMIT MAXIMUM ECONOMY AND EFFICIENCY OF OPERATIONS; (B) SCIENTIFIC PERSONNEL SHALL BE EXCHANGED IN ANTARCTICA BETWEEN EXPEDITIONS AND STATIONS; (C) SCIENTIFIC OBSERVATIONS AND RESULTS FROM ANTARCTICA SHALL BE EXCHANGED AND MADE FREELY AVAILABLE. 2. IN IMPLEMENTING THIS ARTICLE, EVERY ENCOURAGEMENT SHALL BE GIVEN TO THE ESTABLISHMENT OF COOPERATIVE WORKING RELATIONS WITH THOSE SPECIALIZED AGENCIES OF THE UNITED NATIONS AND OTHER INTERNATIONAL ORGANIZATIONS HAVING A SCIENTIFIC OR TECHNICAL INTEREST IN ANTARCTICA. ARTICLE IV 1. NOTHING CONTAINED IN THE PRESENT TREATY SHALL BE INTERPRETED AS: (A) A RENUNCIATION BY ANY CONTRACTING PARTY OF PREVIOUSLY ASSERTED RIGHTS OF OR CLAIMS TO TERRITORIAL SOVEREIGNTY IN ANTARCTICA; (B) A RENUNCIATION OR DIMINUTION BY ANY CONTRACTING PARTY OF ANY BASIS OF CLAIM TO TERRITORIAL SOVEREIGNTY IN ANTARCTICA WHICH IT MAY HAVE WHETHER AS A RESULT OF ITS ACTIVITIES OR THOSE OF ITS NATIONALS IN ANTARCTICA, OR OTHERWISE; (C) PREJUDICING THE POSITION OF ANY CONTRACTING PARTY AS REGARDS ITS RECOGNITION OR NONRECOGNITION OF ANY OTHER STATE'S RIGHT OF OR CLAIM OR BASIS OF CLAIM TO TERRITORIAL SOVEREIGNTY IN ANTARCTICA. 2. NO ACTS OR ACTIVITIES TAKING PLACE WHILE THE PRESENT TREATY IS IN FORCE SHALL CONSTITUTE A BASIS FOR ASSERTING, SUPPORTING OR DENYING A CLAIM TO TERRITORIAL SOVEREIGNTY IN ANTARCTICA OR CREATE ANY RIGHTS OF SOVEREIGNTY IN ANTARCTICA. NO NEW CLAIM, OR ENLARGEMENT OF AN EXISTING CLAIM, TO TERRITORIAL SOVEREIGNTY IN ANTARCTICA SHALL BE ASSERTED WHILE THE PRESENT TREATY IS IN FORCE. ARTICLE V [NUCLEAR EXPLOSIONS PROHIBITED] 1. ANY NUCLEAR EXPLOSIONS IN ANTARCTICA AND THE DISPOSAL THERE OF RADIOACTIVE WASTE MATERIAL SHALL BE PROHIBITED. 2. IN THE EVENT OF THE CONCLUSION OF INTERNATIONAL AGREEMENTS CONCERNING THE USE OF NUCLEAR ENERGY, INCLUDING NUCLEAR EXPLOSIONS AND THE DISPOSAL OF RADIOACTIVE WASTE MATERIAL, TO WHICH ALL OF THE CONTRACTING PARTIES WHOSE REPRESENTATIVES ARE ENTITLED TO PARTICIPATE IN THE MEETINGS PROVIDED FOR UNDER ARTICLE IX ARE PARTIES, THE RULES ESTABLISHED UNDER SUCH AGREEMENTS SHALL APPLY IN ANTARCTICA. ARTICLE VI [AREA COVERED BY TREATY] THE PROVISIONS OF THE PRESENT TREATY SHALL APPLY TO THE AREA SOUTH OF 60° SOUTH LATITUDE, INCLUDING ALL ICE SHELVES, BUT NOTHING IN THE PRESENT TREATY SHALL PREJUDICE OR IN ANY WAY AFFECT THE RIGHTS, OR THE EXERCISE OF THE RIGHTS, OF ANY STATE UNDER INTERNATIONAL LAW WITH REGARD TO THE HIGH SEAS WITHIN THAT AREA. ARTICLE VII 1. IN ORDER TO PROMOTE THE OBJECTIVES AND ENSURE THE OBSERVANCE OF THE PROVISIONS OF THE PRESENT TREATY, EACH CONTRACTING PARTY WHOSE REPRESENTATIVES ARE ENTITLED TO PARTICIPATE IN THE MEETINGS REFERRED TO IN ARTICLE IX OF THE TREATY SHALL HAVE THE RIGHT TO DESIGNATE OBSERVERS TO CARRY OUT ANY INSPECTION PROVIDED FOR BY THE PRESENT ARTICLE. OBSERVERS SHALL BE NATIONALS OF THE CONTRACTING PARTIES WHICH DESIGNATE THEM. THE NAMES OF THE OBSERVERS SHALL BE COMMUNICATED TO EVERY OTHER CONTRACTING PARTY HAVING THE RIGHT TO DESIGNATE OBSERVERS, AND LIKE NOTICE SHALL BE GIVEN OF THE TERMINATION OF THEIR APPOINTMENT. 2. EACH OBSERVER DESIGNATED IN ACCORDANCE WITH THE PROVISIONS OF PARAGRAPH 1 OF THIS ARTICLE SHALL HAVE COMPLETE FREEDOM OF ACCESS AT ANY TIME TO ANY OR ALL AREAS OF ANTARCTICA. 3. ALL AREAS OF ANTARCTICA, INCLUDING ALL STATIONS, INSTALLATIONS AND EQUIPMENT WITHIN THOSE AREAS, AND ALL SHIPS AND AIRCRAFT AT POINTS OF DISCHARGING OR EMBARKING CARGOES OR PERSONNEL IN ANTARCTICA, SHALL BE OPEN AT ALL TIMES TO INSPECTION BY ANY OBSERVERS DESIGNATED IN ACCORDANCE WITH PARAGRAPH 1 OF THIS ARTICLE. 4. AERIAL OBSERVATION MAY BE CARRIED OUT AT ANY TIME OVER ANY OR ALL AREAS OF ANTARCTICA BY ANY OF THE CONTRACTING PARTIES HAVING THE RIGHT TO DESIGNATE OBSERVERS. 5. EACH CONTRACTING PARTY SHALL, AT THE TIME WHEN THE PRESENT TREATY ENTERS INTO FORCE FOR IT, INFORM THE OTHER CONTRACTING PARTIES, AND THEREAFTER SHALL GIVE THEM NOTICE IN ADVANCE, OF (A) ALL EXPEDITIONS TO AND WITHIN ANTARCTICA, ON THE PART OF ITS SHIPS OR NATIONALS, AND ALL EXPEDITIONS TO ANTARCTICA ORGANIZED IN OR PROCEEDING FROM ITS TERRITORY; (B) ALL STATIONS IN ANTARCTICA OCCUPIED BY ITS NATIONALS; AND (C) ANY MILITARY PERSONNEL OR EQUIPMENT INTENDED TO BE INTRODUCED BY IT INTO ANTARCTICA SUBJECT TO THE CONDITIONS PRESCRIBED IN PARAGRAPH 2 OF ARTICLE I OF THE PRESENT TREATY. ARTICLE VIII 1. IN ORDER TO FACILITATE THE EXERCISE OF THEIR FUNCTIONS UNDER THE PRESENT TREATY, AND WITHOUT PREJUDICE TO THE RESPECTIVE POSITIONS OF THE CONTRACTING PARTIES RELATING TO JURISDICTION OVER ALL OTHER PERSONS IN ANTARCTICA, OBSERVERS DESIGNATED UNDER PARAGRAPH 1 OF ARTICLE VII AND SCIENTIFIC PERSONNEL EXCHANGED UNDER SUB-PARAGRAPH 1 (B) OF ARTICLE III OF THE TREATY, AND MEMBERS OF THE STAFFS ACCOMPANYING ANY SUCH PERSONS, SHALL BE SUBJECT ONLY TO THE JURISDICTION OF THE CONTRACTING PARTY OF WHICH THEY ARE NATIONALS IN RESPECT OF ALL ACTS OR OMISSIONS OCCURRING WHILE THEY ARE IN ANTARCTICA FOR THE PURPOSE OF EXERCISING THEIR FUNCTIONS. 2. WITHOUT PREJUDICE TO THE PROVISIONS OF PARAGRAPH 1 OF THIS ARTICLE, AND PENDING THE ADOPTION OF MEASURES IN PURSUANCE OF SUBPARAGRAPH 1 (E) OF ARTICLE IX, THE CONTRACTING PARTIES CONCERNED IN ANY CASE OF DISPUTE WITH REGARD TO THE EXERCISE OF JURISDICTION IN ANTARCTICA SHALL IMMEDIATELY CONSULT TOGETHER WITH A VIEW TO REACHING A MUTUALLY ACCEPTABLE SOLUTION. ARTICLE IX [TREATY REVIEW] 1. REPRESENTATIVES OF THE CONTRACTING PARTIES NAMED IN THE PREAMBLE TO THE PRESENT TREATY SHALL MEET AT THE CITY OF CANBERRA WITHIN TWO MONTHS AFTER THE DATE OF ENTRY INTO FORCE OF THE TREATY, AND THEREAFTER AT SUITABLE INTERVALS AND PLACES, FOR THE PURPOSE OF EXCHANGING INFORMATION, CONSULTING TOGETHER ON MATTERS OF COMMON INTEREST PERTAINING TO ANTARCTICA, AND FORMULATING AND CONSIDERING, AND RECOMMENDING TO THEIR GOVERNMENTS, MEASURES IN FURTHERANCE OF THE PRINCIPLES AND OBJECTIVES OF THE TREATY, INCLUDING MEASURES REGARDING: (A) USE OF ANTARCTICA FOR PEACEFUL PURPOSES ONLY; (B) FACILITATION OF SCIENTIFIC RESEARCH IN ANTARCTICA; (C) FACILITATION OF INTERNATIONAL SCIENTIFIC COOPERATION IN ANTARCTICA; (D) FACILITATION OF THE EXERCISE OF THE RIGHTS OF INSPECTION PROVIDED FOR IN ARTICLE VII OF THE TREATY; (E) QUESTIONS RELATING TO THE EXERCISE OF JURISDICTION IN ANTARCTICA; (F) PRESERVATION AND CONSERVATION OF LIVING RESOURCES IN ANTARCTICA. 2. EACH CONTRACTING PARTY WHICH HAS BECOME A PARTY TO THE PRESENT TREATY BY ACCESSION UNDER ARTICLE XIII SHALL BE ENTITLED TO APPOINT REPRESENTATIVES TO PARTICIPATE IN THE MEETINGS REFERRED TO IN PARAGRAPH 1 OF THE PRESENT ARTICLE, DURING SUCH TIME AS THAT CONTRACTING PARTY DEMONSTRATES ITS INTEREST IN ANTARCTICA BY CONDUCTING SUBSTANTIAL SCIENTIFIC RESEARCH ACTIVITY THERE, SUCH AS THE ESTABLISHMENT OF A SCIENTIFIC STATION OR THE DESPATCH OF A SCIENTIFIC EXPEDITION. 3. REPORTS FROM THE OBSERVERS REFERRED TO IN ARTICLE VII OF THE PRESENT TREATY SHALL BE TRANSMITTED TO THE REPRESENTATIVES OF THE CONTRACTING PARTIES PARTICIPATING IN THE MEETINGS REFERRED TO IN PARAGRAPH 1 OF THE PRESENT ARTICLE. 4. THE MEASURES REFERRED TO IN PARAGRAPH 1 OF THIS ARTICLE SHALL BECOME EFFECTIVE WHEN APPROVED BY ALL THE CONTRACTING PARTIES WHOSE REPRESENTATIVES WERE ENTITLED TO PARTICIPATE IN THE MEETINGS HELD TO CONSIDER THOSE MEASURES. 5. ANY OR ALL OF THE RIGHTS ESTABLISHED IN THE PRESENT TREATY MAY BE EXERCISED AS FROM THE DATE OF ENTRY INTO FORCE OF THE TREATY WHETHER OR NOT ANY MEASURES FACILITATING THE EXERCISE OF SUCH RIGHTS HAVE BEEN PROPOSED, CONSIDERED OR APPROVED AS PROVIDED IN THIS ARTICLE. ARTICLE X EACH OF THE CONTRACTING PARTIES UNDERTAKES TO EXERT APPROPRIATE EFFORTS, CONSISTENT WITH THE CHARTER OF THE UNITED NATIONS, TO THE END THAT NO ONE ENGAGES IN ANY ACTIVITY IN ANTARCTICA CONTRARY TO THE PRINCIPLES OR PURPOSES OF THE PRESENT TREATY. ARTICLE XI 1. IF ANY DISPUTE ARISES BETWEEN TWO OR MORE OF THE CONTRACTING PARTIES CONCERNING THE INTERPRETATION OR APPLICATION OF THE PRESENT TREATY, THOSE CONTRACTING PARTIES SHALL CONSULT AMONG THEMSELVES WITH A VIEW TO HAVING THE DISPUTE RESOLVED BY NEGOTIATION, INQUIRY, MEDIATION, CONCILIATION, ARBITRATION, JUDICIAL SETTLEMENT OR OTHER PEACEFUL MEANS OF THEIR OWN CHOICE. 2. ANY DISPUTE OF THIS CHARACTER NOT SO RESOLVED SHALL, WITH THE CONSENT, IN EACH CASE, OF ALL PARTIES TO THE DISPUTE, BE REFERRED TO THE INTERNATIONAL COURT OF JUSTICE FOR SETTLEMENT; BUT FAILURE TO REACH AGREEMENT ON REFERENCE TO THE INTERNATIONAL COURT SHALL NOT ABSOLVE PARTIES TO THE DISPUTE FROM THE RESPONSIBILITY OF CONTINUING TO SEEK TO RESOLVE IT BY ANY OF THE VARIOUS PEACEFUL MEANS REFERRED TO IN PARAGRAPH 1 OF THIS ARTICLE. ARTICLE XII [REVIEW OF TREATY PROVISIONS] 1. (A) THE PRESENT TREATY MAY BE MODIFIED OR AMENDED AT ANY TIME BY UNANIMOUS AGREEMENT OF THE CONTRACTING PARTIES WHOSE REPRESENTATIVES ARE ENTITLED TO PARTICIPATE IN THE MEETINGS PROVIDED FOR UNDER ARTICLE IX. ANY SUCH MODIFICATION OR AMENDMENT SHALL ENTER INTO FORCE WHEN THE DEPOSITARY GOVERNMENT HAS RECEIVED NOTICE FROM ALL SUCH CONTRACTING PARTIES THAT THEY HAVE RATIFIED IT. (B) SUCH MODIFICATION OR AMENDMENT IN ACCORDANCE WITH THE OTHER CONTRACTING PARTIES ON THE DATE OF RATIFICATION IS RECEIVED BY THE DEPOSITARY GOVERNMENT. ANY SUCH CONTRACTING PARTY FROM WHICH NO NOTICE OF RATIFICATION IS RECEIVED WITHIN A PERIOD OF TWO YEARS FROM THE DATE OF ENTRY INTO FORCE OF THE MODIFICATION OR AMENDMENT IN ACCORDANCE WITH THE PROVISIONS OF SUB-PARAGRAPH 1(A) OF THIS ARTICLE SHALL BE DEEMED TO HAVE WITHDRAWN FROM THE PRESENT TREATY ON THE DATE OF THE EXPIRATION OF SUCH PERIOD. 2. (A) IF AFTER THE EXPIRATION OF THIRTY YEARS FROM THE DATE OF ENTRY INTO FORCE OF THE PRESENT TREATY, ANY OF THE CONTRACTING PARTIES WHOSE REPRESENTATIVES ARE ENTITLED TO PARTICIPATE IN THE MEETINGS PROVIDED FOR UNDER ARTICLE IX SO REQUESTS BY A COMMUNICATION ADDRESSED TO THE DEPOSITARY GOVERNMENT, A CONFERENCE OF ALL THE CONTRACTING PARTIES SHALL BE HELD AS SOON AS PRACTICABLE TO REVIEW THE OPERATION OF THE TREATY. (B) ANY MODIFICATION OR AMENDMENT TO THE PRESENT TREATY WHICH IS APPROVED AT SUCH A CONFERENCE BY A MAJORITY OF THE CONTRACTING PARTIES THERE REPRESENTED, INCLUDING A MAJORITY OF THOSE WHOSE REPRESENTATIVES ARE ENTITLED TO PARTICIPATE IN THE MEETINGS PROVIDED FOR UNDER ARTICLE IX, SHALL BE COMMUNICATED BY THE DEPOSITARY GOVERNMENT TO ALL THE CONTRACTING PARTIES IMMEDIATELY AFTER THE TERMINATION OF THE CONFERENCE AND SHALL ENTER INTO FORCE IN ACCORDANCE WITH THE PROVISIONS OF PARAGRAPH 1 OF THE PRESENT ARTICLE. (C) IF ANY SUCH MODIFICATION OR AMENDMENT HAS NOT ENTERED INTO FORCE IN ACCORDANCE WITH THE PROVISIONS OF SUB-PARAGRAPH 1(A) OF THIS ARTICLE WITHIN A PERIOD OF TWO YEARS AFTER THE DATE OF ITS COMMUNICATION TO ALL THE CONTRACTING PARTIES, ANY CONTRACTING PARTY MAY AT ANY TIME AFTER THE EXPIRATION OF THAT PERIOD GIVE NOTICE TO THE DEPOSITARY GOVERNMENT OF ITS WITHDRAWAL FROM THE PRESENT TREATY; AND SUCH WITHDRAWAL SHALL TAKE EFFECT TWO YEARS AFTER THE RECEIPT OF THE NOTICE BY THE DEPOSITARY GOVERNMENT. ARTICLE XIII [RATIFICATION AND ACCESSION] 1. THE PRESENT TREATY SHALL BE SUBJECT TO RATIFICATION BY THE SIGNATORY STATES. IT SHALL BE OPEN FOR ACCESSION BY ANY STATE WHICH IS A MEMBER OF THE UNITED NATIONS, OR BY ANY OTHER STATE WHICH MAY BE INVITED TO ACCEDE TO THE TREATY WITH THE CONSENT OF ALL THE CONTRACTING PARTIES WHOSE REPRESENTATIVES ARE ENTITLED TO PARTICIPATE IN THE MEETINGS PROVIDED FOR UNDER ARTICLE IX OF THE TREATY. 2. RATIFICATION OF OR ACCESSION TO THE PRESENT TREATY SHALL BE EFFECTED BY EACH STATE IN ACCORDANCE WITH ITS CONSTITUTIONAL PROCESSES. 3. INSTRUMENTS OF RATIFICATION AND INSTRUMENTS OF ACCESSION SHALL BE DEPOSITED WITH THE GOVERNMENT OF THE UNITED STATES OF AMERICA, HEREBY DESIGNATED AS THE DEPOSITARY GOVERNMENT. 4. THE DEPOSITARY GOVERNMENT SHALL INFORM ALL SIGNATORY AND ACCEDING STATES OF THE DATE OF EACH DEPOSIT OF INSTRUMENT OF RATIFICATION OR ACCESSION, AND THE DATE OF ENTRY INTO FORCE OF THE TREATY AND OF ANY MODIFICATION OR AMENDMENT THERETO. 5. UPON THE DEPOSIT OF INSTRUMENTS OF RATIFICATION BY ALL THE SIGNATORY STATES, THE PRESENT TREATY SHALL ENTER INTO FORCE FOR THOSE STATES AND FOR STATES WHICH HAVE DEPOSITED INSTRUMENTS OF ACCESSION. THEREAFTER THE TREATY SHALL ENTER INTO FORCE FOR ANY ACCEDING STATE UPON THE DEPOSIT OF ITS INSTRUMENT OF ACCESSION. 6. THE PRESENT TREATY SHALL BE REGISTERED BY THE DEPOSITARY GOVERNMENT PURSUANT TO ARTICLE 102 OF THE CHARTER OF THE UNITED NATIONS. ARTICLE XIV [UNITED STATES IS REPOSITORY] THE PRESENT TREATY, DONE IN THE ENGLISH, FRENCH, RUSSIAN, AND SPANISH LANGUAGES, EACH VERSION BEING EQUALLY AUTHENTIC, SHALL BE DEPOSITED IN THE ARCHIVES OF THE GOVERNMENT OF THE UNITED STATES OF AMERICA, WHICH SHALL TRANSMIT DULY CERTIFIED COPIES THEREOF TO THE GOVERNMENTS OF THE SIGNATORY AND ACCEDING STATES. IN WITNESS WHEREOF, THE UNDERSIGNED PLENIPOTENTIARIES, DULY AUTHORIZED, HAVE SIGNED THE PRESENT TREATY. DONE AT WASHINGTON THE FIRST DAY OF DECEMBER, ONE THOUSAND NINE HUNDRED AND FIFTY-NINE. FOR ARGENTINA: ADOLFO F. BELLO FOR AUSTRALIA: HOWARD BEALE FOR BELGIUM: OBERT DE THIEUSIES FOR CHILE: MARCIAL MORA M. L. GAJARDO V. JULIO ESCUDERO FOR THE FRENCH REPUBLIC: PIERRE CHARPENTIER FOR JAPAN: KOICHIRO ASAKAI T. SHIMODA FOR NEW ZEALAND: G.D.L. WHITE FOR NORWAY: PAUL KOHT FOR THE UNION OF SOUTH AFRICA: WENTZEL C. DU PLESSIS FOR THE UNION OF SOVIET SOCIALIST REPUBLICS: V. KUZNETSOV FOR THE UNITED KINGDOM OF GREAT BRITAIN AND NORTHERN IRELAND: HAROLD CACCIA FOR THE UNITED STATES OF AMERICA: HERMAN PHLEGER PAUL C. DANIELS

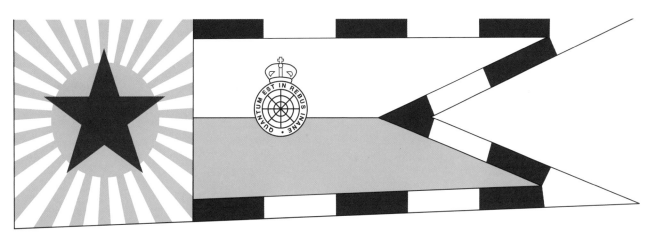

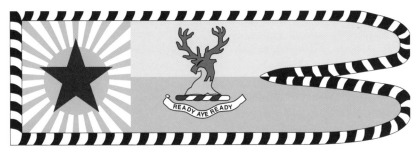

ECONOMIC LANDSCAPE

Leo Tolstoy wrote, "Music is the shorthand of emotion," which is some-thing like a bootleg mix of the issues driving the material in this chapter. When you look at how economics shapes and molds every aspect of the climate change debate, it's hard not to remark on how remote economics and lifestyle have become from the heart of the matter. The mathematics of climate change and scientific analysis are part and parcel of how we engage everything around us. They don't seem to be open to debate, yet climate skeptics keep braying and moaning as if the world should leap and conform to their vision, which would make everything okay.

This section looks at a certain kind of digital literacy and asks, "Do you really think that Sarah Palin understands how the weather in Antarctica works?" Juxtapose this with Adam Smith's infamous phrase that "money is a belief" and you are drawn to think of art and music and economics as a new kind of currency. The first person to make this kind of observation was not a musician but a painter. Luigi Russolo's 1913 book *The Art of Noises* created a revolution in sound that reverberates to this day. His manifesto demanded the "renewal of music by means of the Art of Noises." When you listen to composers such as Edgard Varese, Pierre Boulez, Iannis Xenakis, Karlheinz Stockhausen, and John Cage, you can hear echoes of the ideas that led to the sounds of our new urban economic landscape becoming a core part of our musical vocabulary. This section looks at these kinds of concepts turned into material for aesthetics and economics. Could this be visual hip-hop?

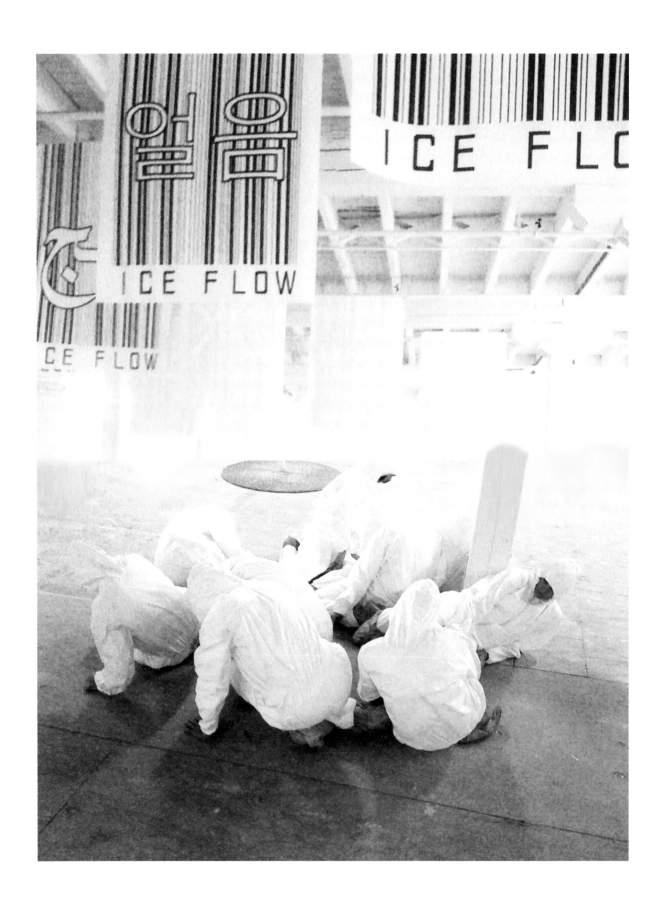

ICE FLOW

ICE FLOW

ICE FLOW

ICE FLOW

ICE FLOW

ICE FLOW

ICE FLOW

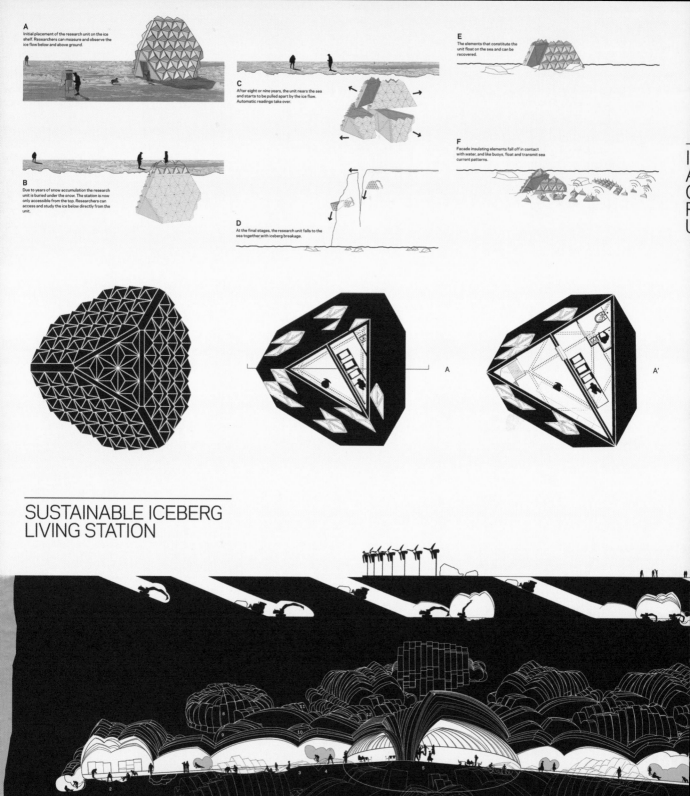

A
Initial placement of the research unit on the ice shelf. Researchers can measure and observe the ice flow below and above ground.

B
Due to years of snow accumulation the research unit is buried under the snow. The station is now only accessible from the top. Researchers can access and study the ice below directly from the unit.

C
After eight or nine years, the unit nears the sea and starts to be pulled apart by the ice flow. Automatic readings take over.

D
At the final stages, the research unit falls to the sea together with iceberg breakage.

E
The elements that constitute the unit float on the sea and can be recovered.

F
Facade insulating elements fall off in contact with water, and like buoys, float and transmit sea current patterns.

SUSTAINABLE ICEBERG LIVING STATION

ENERGY REQUIREMENTS

1 PERSON USES EACH DAY: 4 - 5 kWh
• 20 m2 photovoltaic panels (2.5 kWh)
• 1 windmill (5 kWh)
130 L drink and showering water
• 0.13 m3 melted snow

1 PERSON CREATES EACH DAY:
13.6 L garbage and grey water

100 PEOPLE USE EACH DAY: 400 - 500 kWh
• 2 000 m2 photovoltaic panels (250 kWh)
• 45 windmills (225 kWh)
13 000 L drink and showering water
13 m3 melted snow

100 PEOPLE CREATE EACH DAY:
1 360 L garbage and grey water

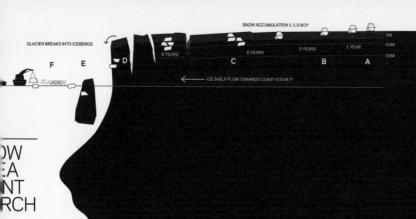

GLACIER BREAKS INTO ICEBERGS

SNOW ACCUMULATION 1-1.5 M /Y

5M
10M
20M

9 YEARS 6 YEARS 3 YEARS 1 YEAR

F E D C B A

ICE SHELF FLOW TOWARDS COAST 400 M /Y

OW
EA
NT
RCH

MAP
Manual of Architectural Possibilities 001
ANTARCTICA

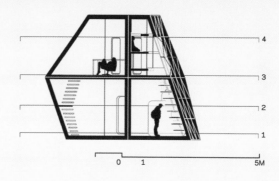

4

3

2

1

0 1 5M

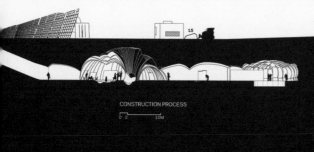

15

CONSTRUCTION PROCESS

0 2 10M

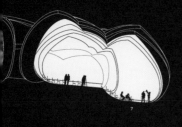

7

SECTION IN PERSPECTIVE

0 2 10M

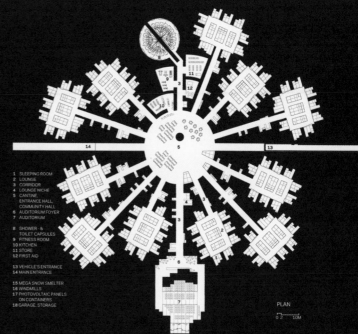

14 13

1 SLEEPING ROOM
2 LOUNGE
3 CORRIDOR
4 LOUNGE NICHE
5 CANTINE,
 ENTRANCE HALL,
 COMMUNITY HALL
6 AUDITORIUM FOYER
7 AUDITORIUM

8 SHOWER- &
 TOILET CAPSULES
9 FITNESS ROOM
10 KITCHEN
11 STORE
12 FIRST AID

13 VEHICLE'S ENTRANCE
14 MAIN ENTRANCE

15 MEGA SNOW SMELTER
16 WINDMILLS
17 PHOTOVOLTAIC PANELS
 ON CONTAINERS
18 GARAGE, STORAGE

PLAN

0 2 10M

READY MADE ANTARCTIC BASE STATION

ECONOMIC INSTABILITIES
+
NATURAL AGING OF AIRCRAFTS

=

20 AIRPLANES RETIRED PER MONTH

=

BOEING 747 SECTION

BOEING 767 SECTION

ICE CORE DRILLING SECTION

0 1 5M

PLAN AND POTENTIAL GROWTH OF THE BASE STATION

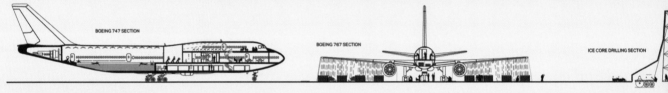

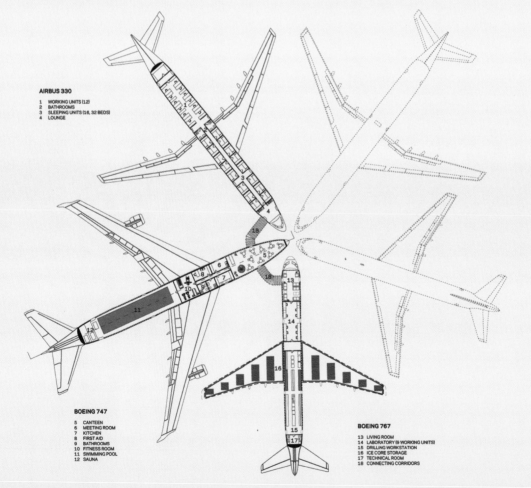

AIRBUS 330

1 WORKING UNITS (12)
2 BATHROOMS
3 SLEEPING UNITS (16, 32 BEDS)
4 LOUNGE

BOEING 747

5 CANTEEN
6 MEETING ROOM
7 KITCHEN
8 FIRST AID
9 BATHROOMS
10 FITNESS ROOM
11 SWIMMING POOL
12 SAUNA

BOEING 767

13 LIVING ROOM
14 LABORATORY (9 WORKING UNITS)
15 DRILLING WORKSTATION
16 ICE CORE STORAGE
17 TECHNICAL ROOM
18 CONNECTING CORRIDORS

AIRCRAFTS PER MONTH

■ DELIVERIES
■ RETIREMENTS
■ PARKED (NET)

-40 20 80 140 200

2006
2007
APRIL-08
MAY-08
JUN-08
JUL-08
AUG-08
SEP-08
OCT-08

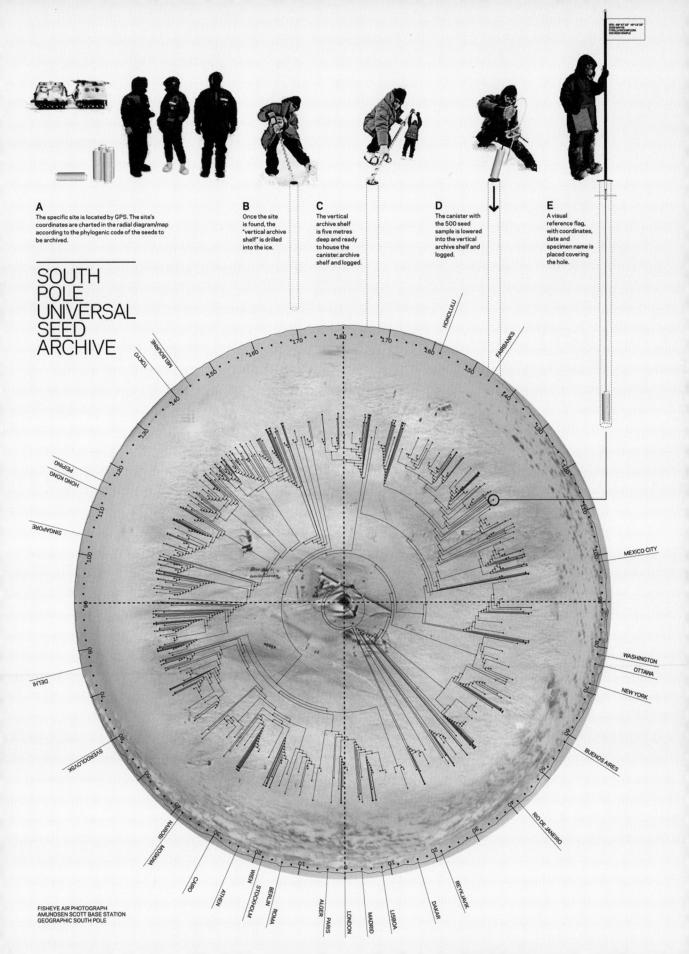

A
The specific site is located by GPS. The site's coordinates are charted in the radial diagram/map according to the phylogenic code of the seeds to be archived.

B
Once the site is found, the "vertical archive shelf" is drilled into the ice.

C
The vertical archive shelf is five metres deep and ready to house the canister.archive shelf and logged.

D
The canister with the 500 seed sample is lowered into the vertical archive shelf and logged.

E
A visual reference flag, with coordinates, date and specimen name is placed covering the hole.

SOUTH POLE UNIVERSAL SEED ARCHIVE

FISHEYE AIR PHOTOGRAPH
AMUNDSEN SCOTT BASE STATION
GEOGRAPHIC SOUTH POLE

EMOTIONAL LANDSCAPE

Ralph Waldo Emerson wrote: "For everything you have missed, you have gained something else, and for everything you gain, you lose something else." I like to think of the visual elements in this book as a Rorschach Test that each of us can remix to see whatever shape we look for. In an interview with *The Wire*, Brazilian singer Caetano Veloso pointed out that you can hear Cagean echoes in the Beatles' "Revolution 9"—but you can also hear them in "The Adventures of Grandmaster Flash on the Wheels of Steel." You just have to listen for them.

Music is a blank manuscript for me. Sampling leaves everything open to interpretation. When John Cage came up with his idea of just letting sounds be themselves, he really struck a resonance. He was the first composer to write for turntables, and his 1939 composition *Imaginary Landscape No. 1* still holds title to the first composition to really look at turntables as the generator of new compositions. The mostly historical photographs in this section are records of moments in time that today need to be re-evaluated. Products of old boundaries that are no longer useful, we must think about how to overcome them, or re-invent them, as Cage advocated. Use these old records to create something anew.

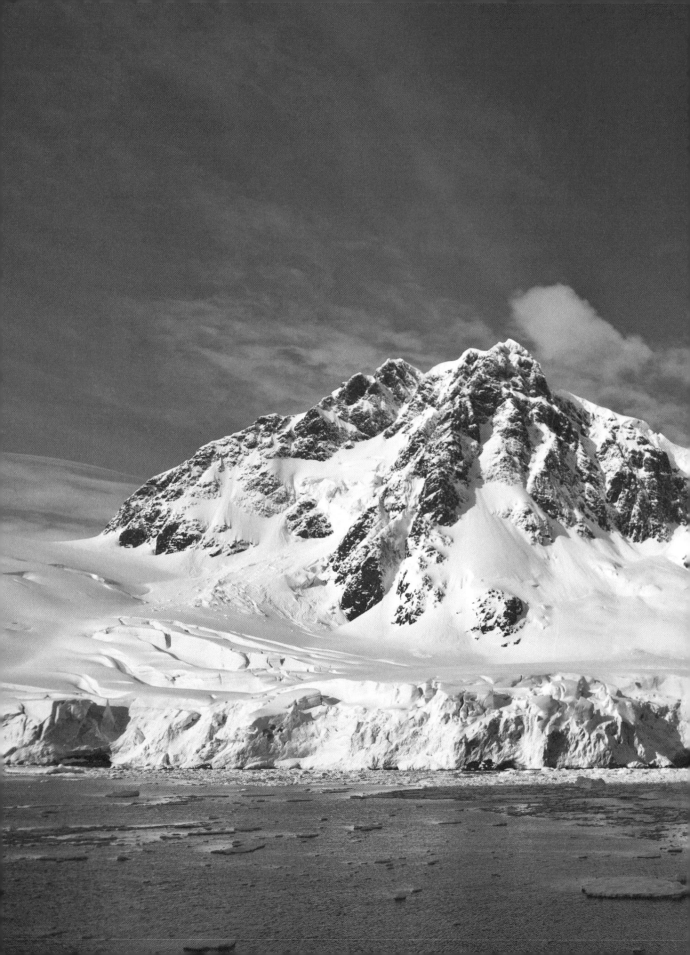

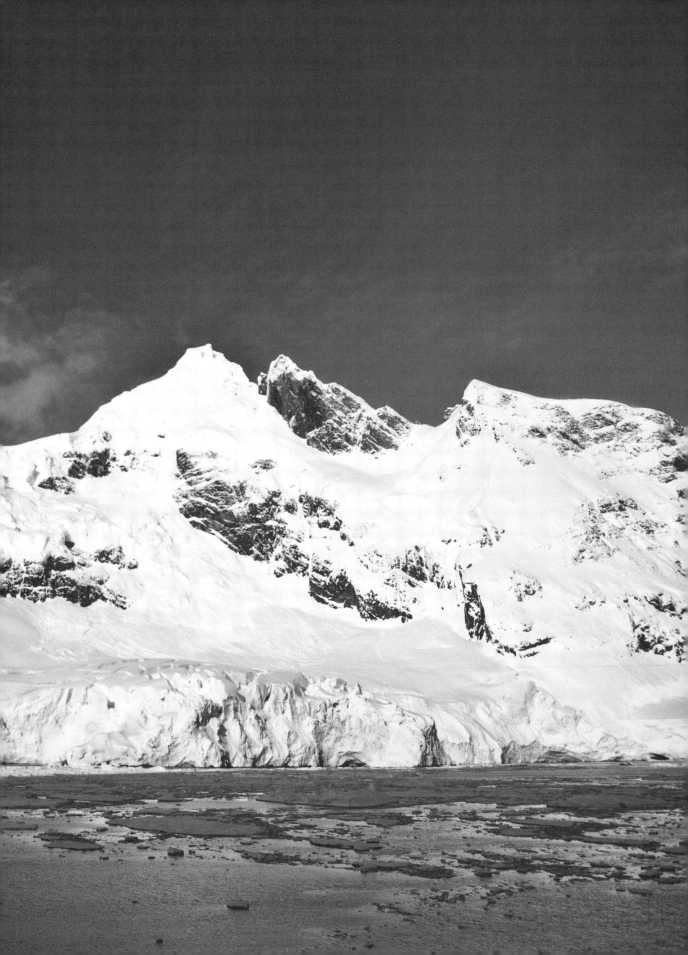

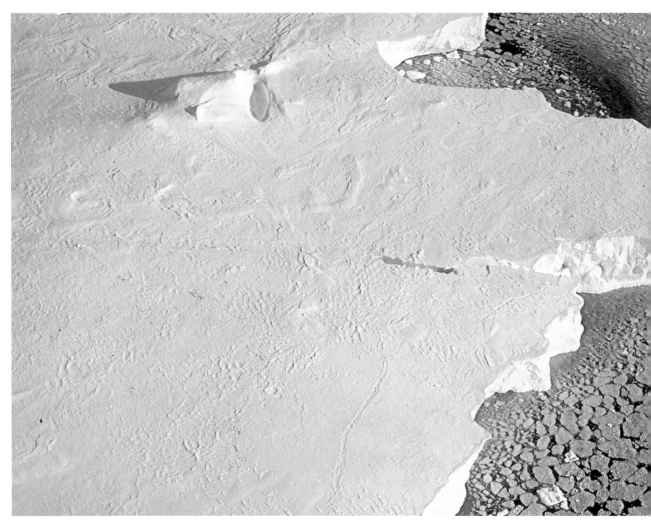

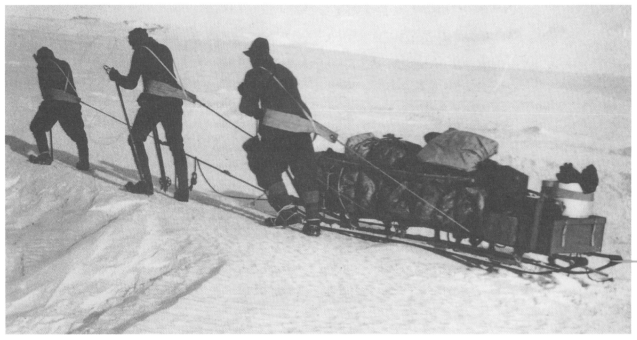

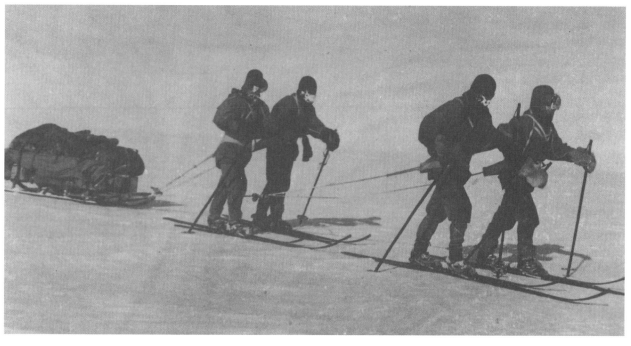

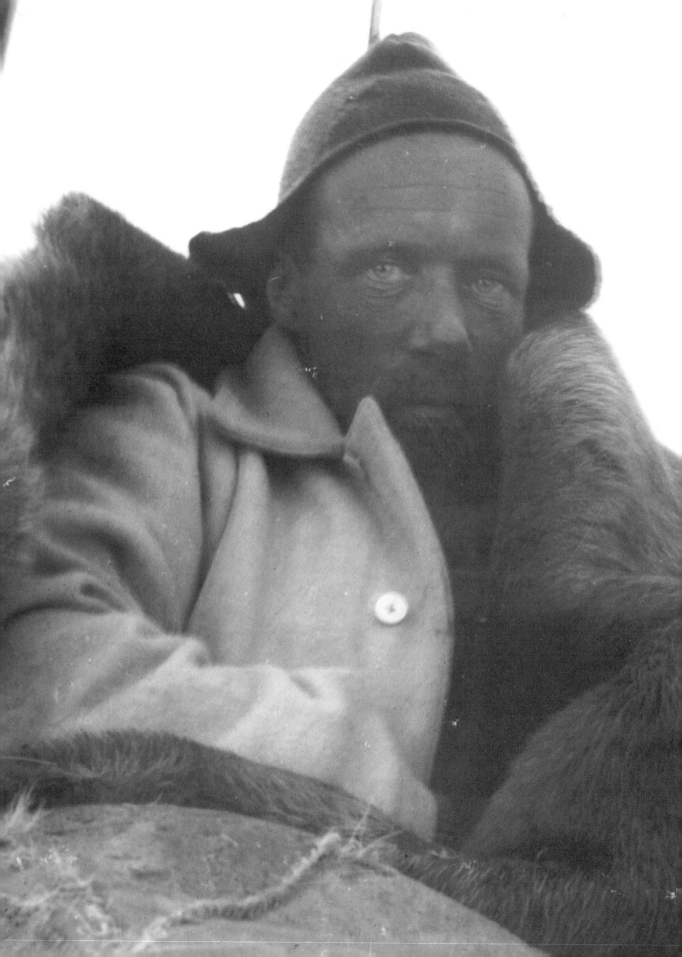

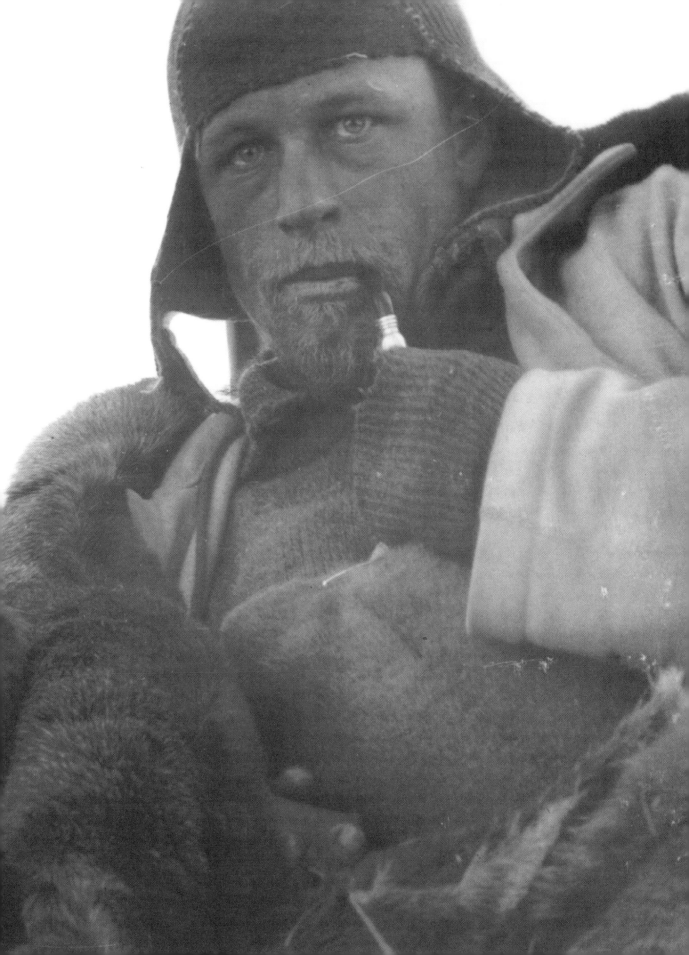

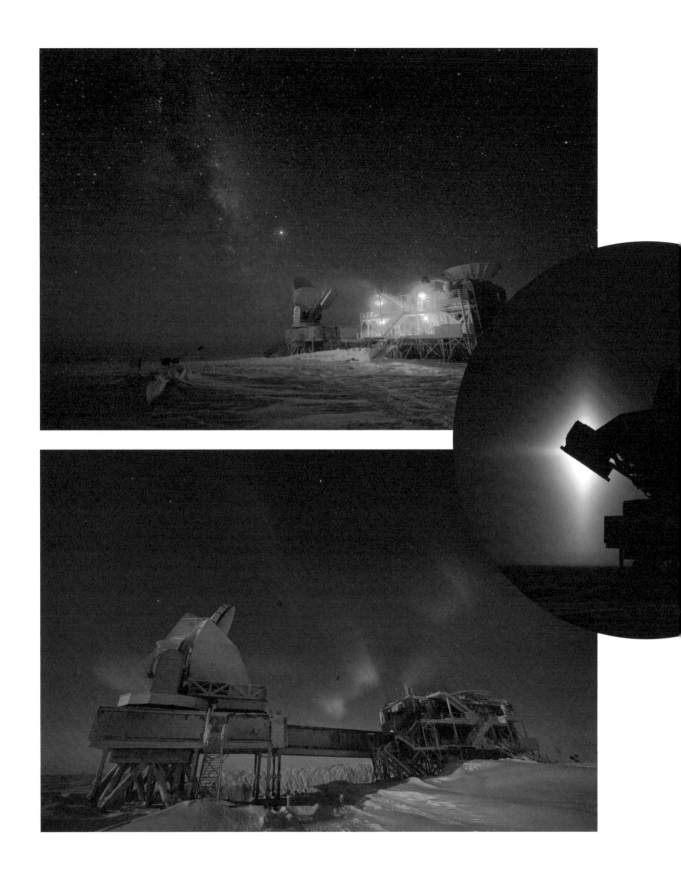

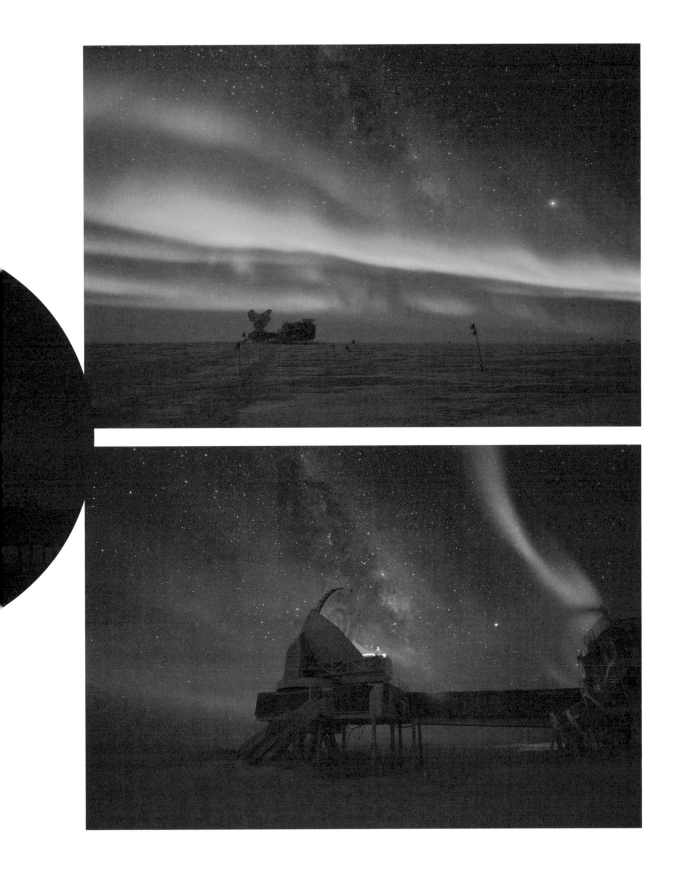

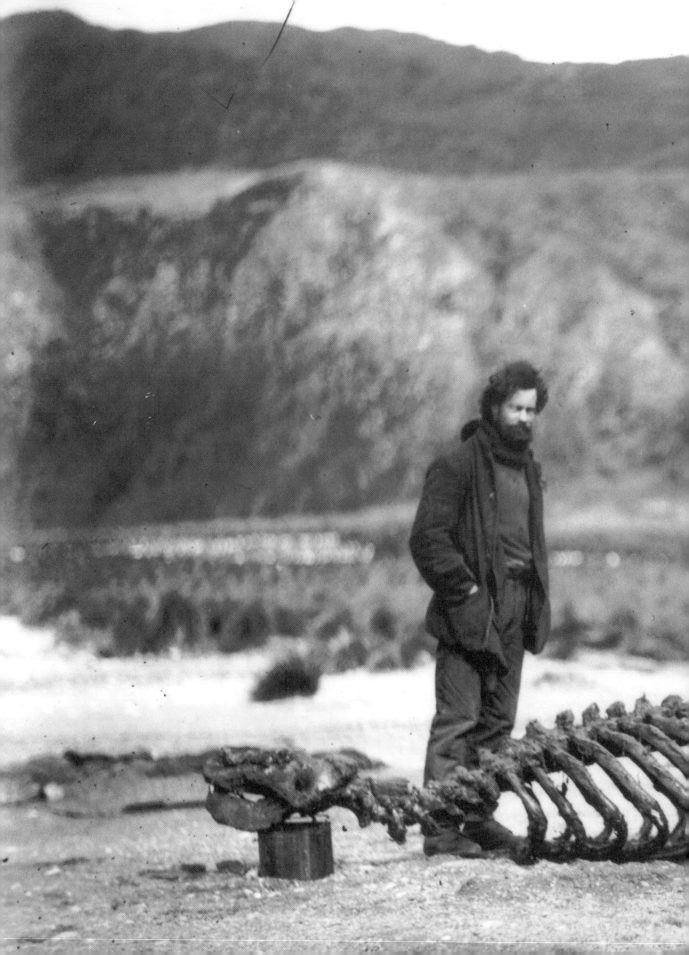

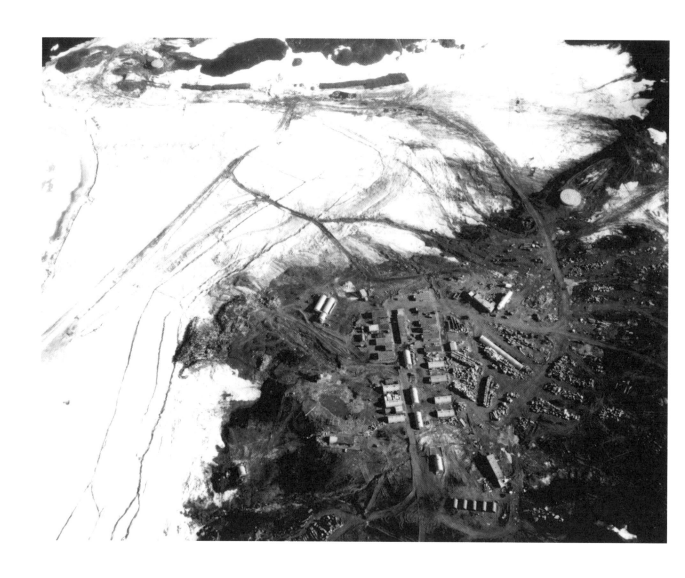

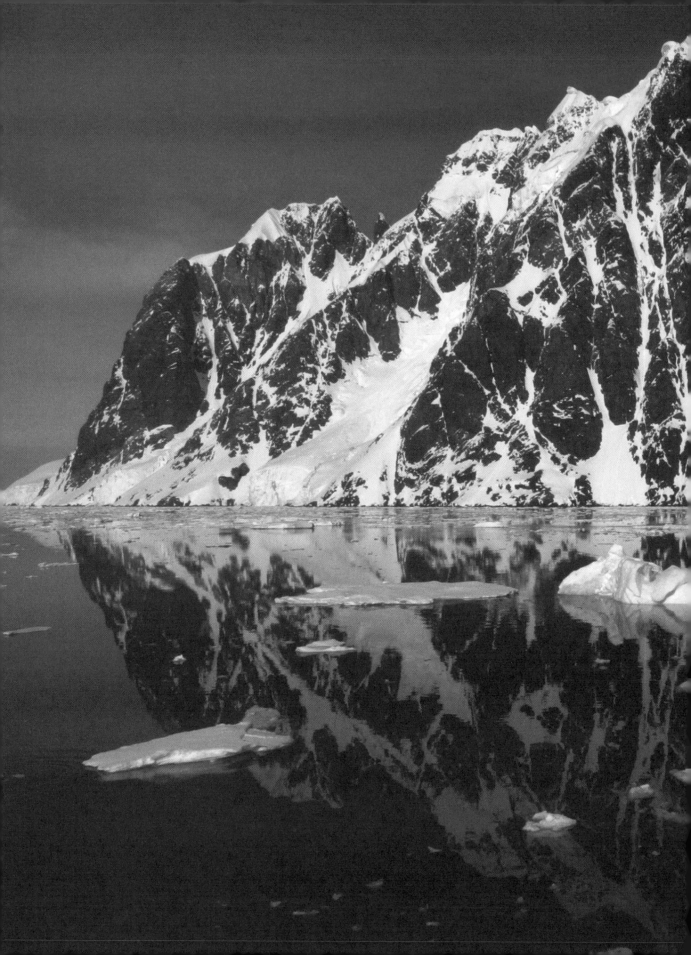

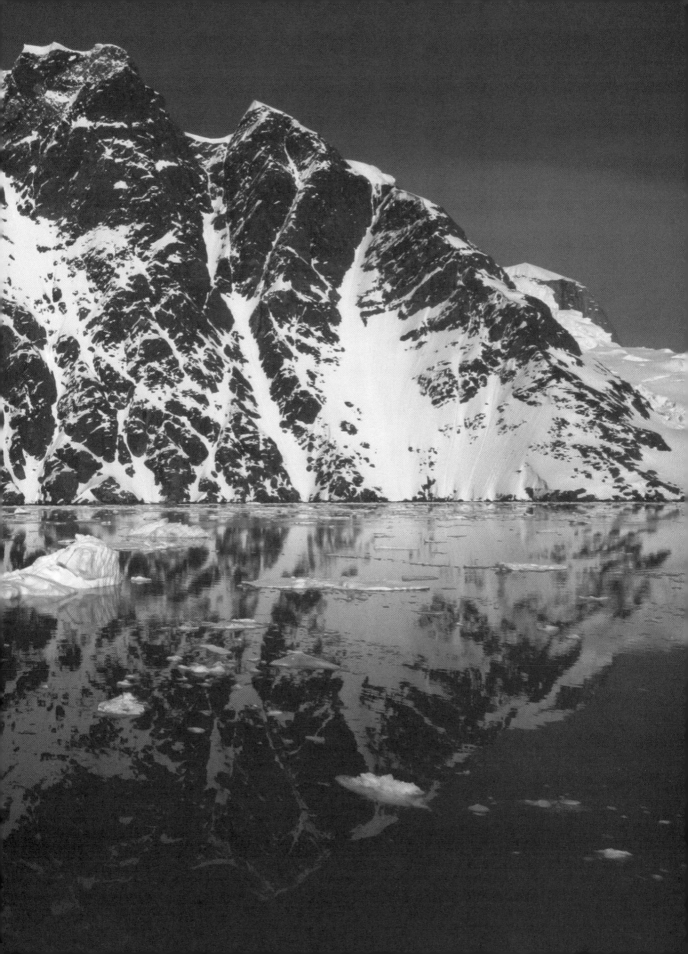

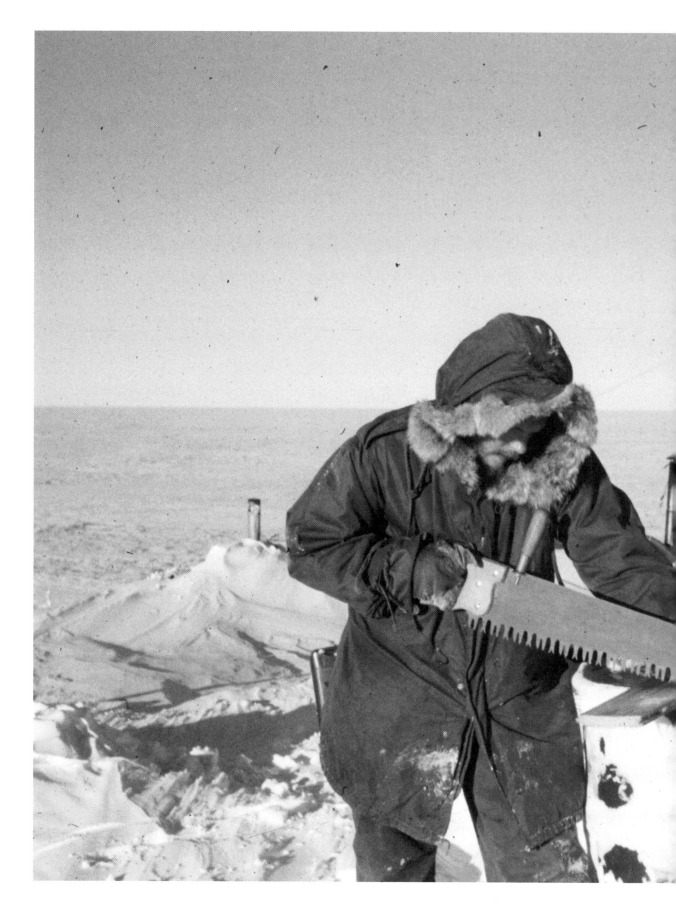

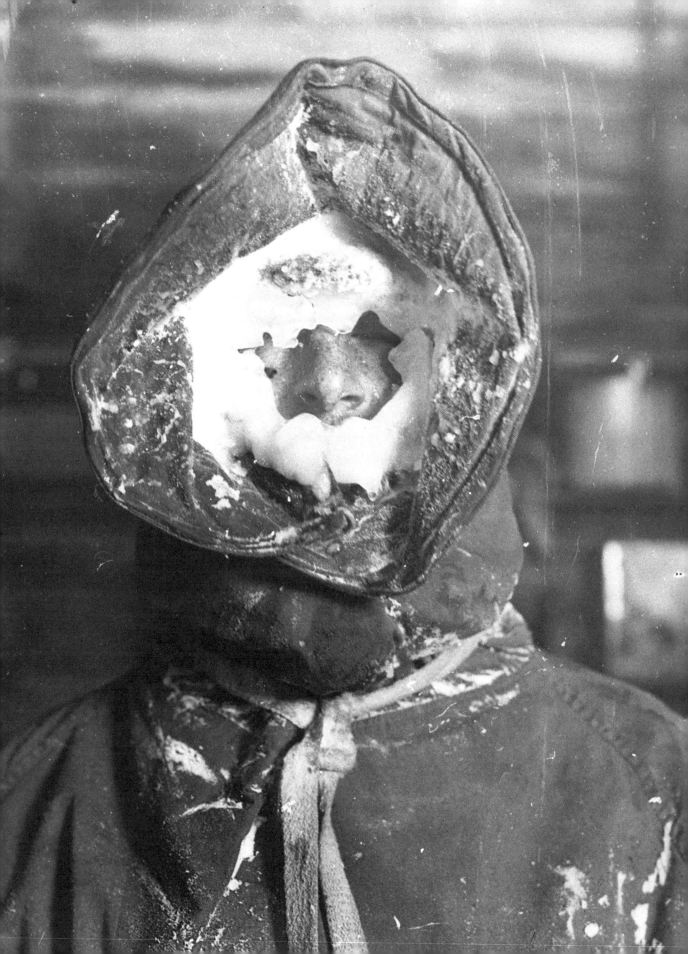

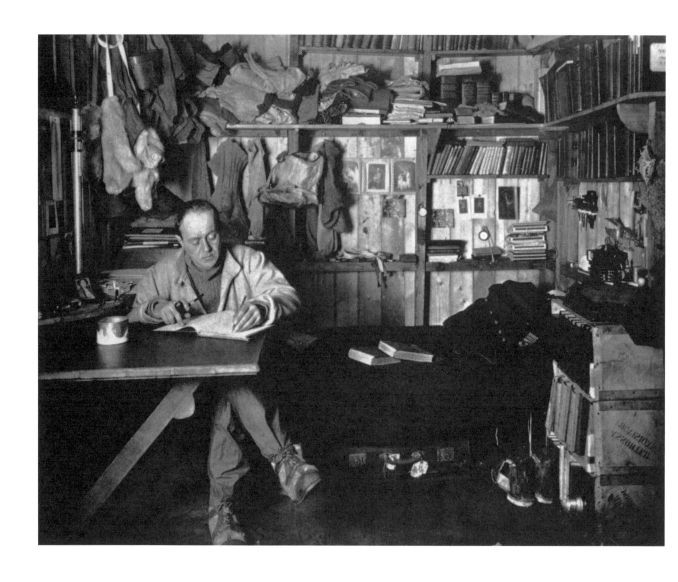

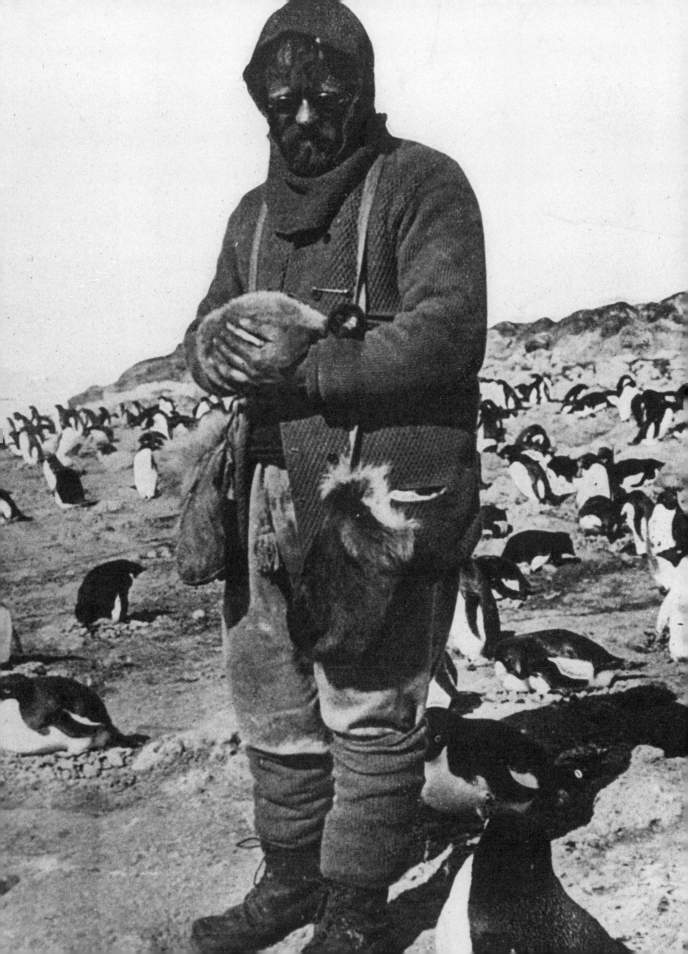

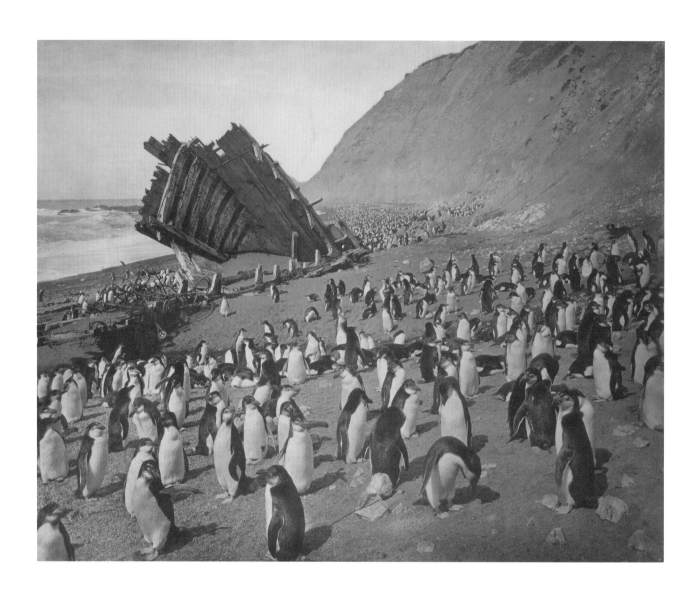

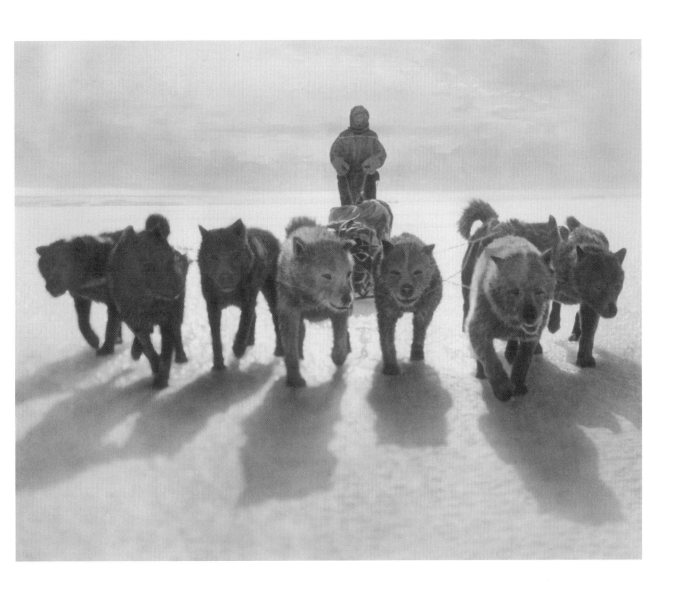

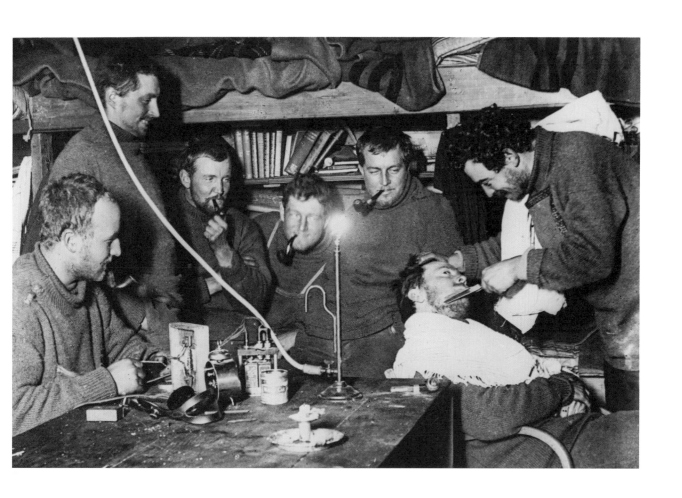

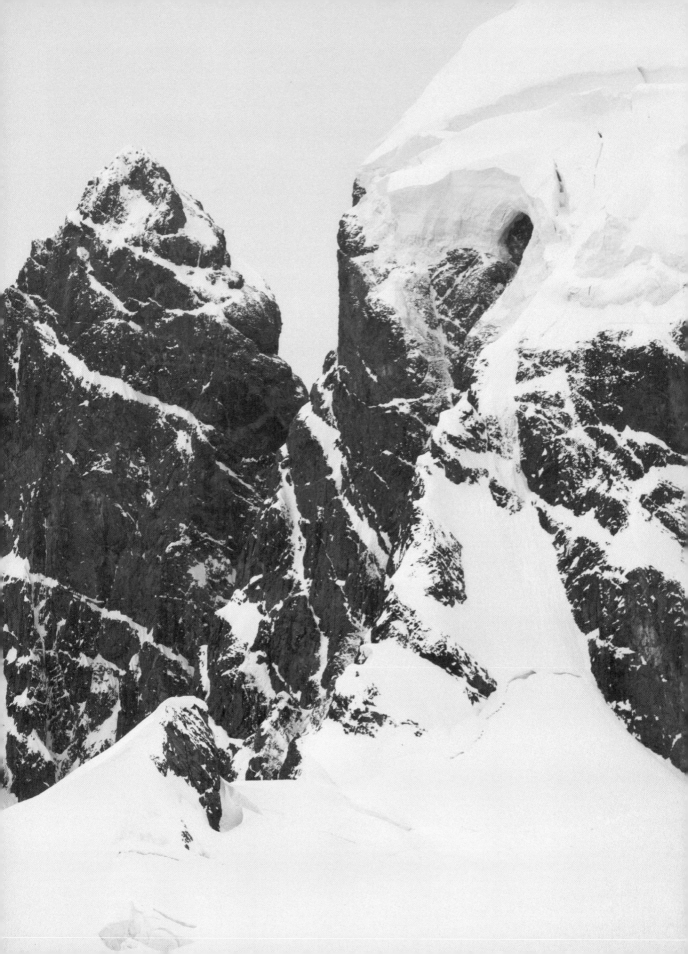

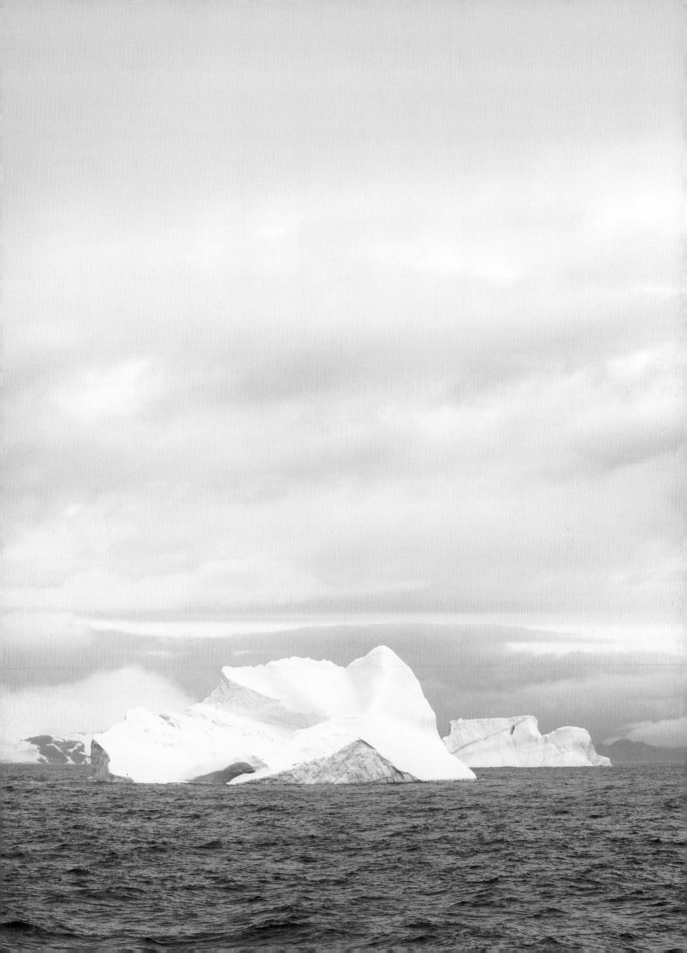

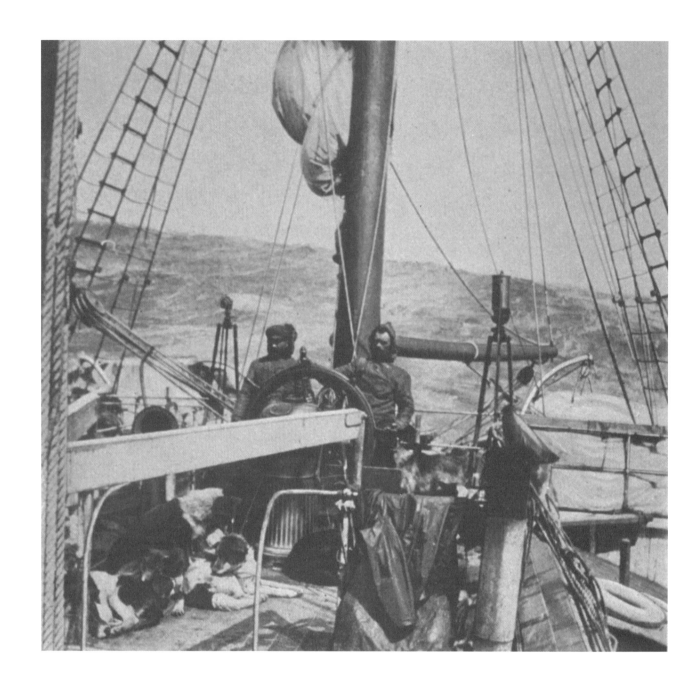

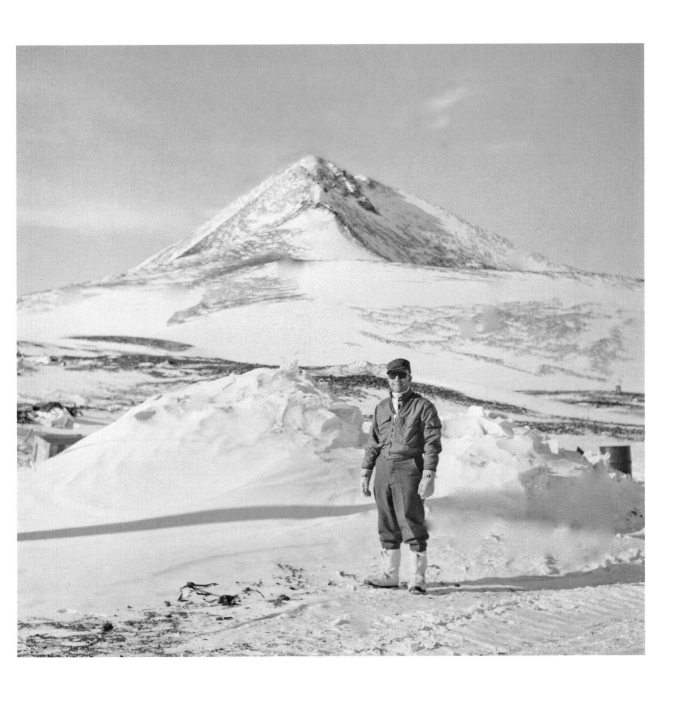

OSMOTIC STRATEGY MACHINE—THE (FLAWED) UNFOLDING OF AFROFUTURISM
TOBIAS C. VAN VEEN IN CONVERSATION WITH PAUL D. MILLER

 TOBIAS C. VAN VEEN

 PAUL D. MILLER

W.E.B. Dubois infamously remarked that the problem of the twentieth century would be the "color line." In the realm of Afrofuturist thought, some of the issues driving that statement are put in a context where fact and fiction blur to the point where they generate new permutations of one another. Who couldn't see the Iraq War, for example, as one huge fiction with a multitrillion dollar price tag? I like to think of my engagement with Afrofuturist thinking as a renewal of tools of skepticism to question the questions themselves. Question everything. Including the will to question everything. That's my mode. Antarctica isn't a place where you think about "blackness," which is exactly why I decided to include this interview. Let's push boundaries, shuffle the deck of perceived expectations and see what pops out. In Antarctica, there is no color line. It's a panhumanist space.

You talk about Afrofuturism in the past tense. Why? Is it a historical moment for you? Or can the word be used like jazz, hip-hop, deconstruction, or philosophy itself?

Every movement has its sell-by date. I think that there were a lot of flaws in the way Afrofuturism unfolded, and I think it missed certain pressure points in the flow of how culture evolves in this day and age. It wasn't digital enough, it didn't have a core group of people with any kind of coherent message. It was conceptually open ended without any kind of narrative. People tend to like that kind of thing. I speak of Afrofuturism in the past tense because I think that the culture at large caught up to and bypassed many of the issues it was dealing with. Forget the idea of the "permanent underclass" that people like Greg Tate (no disrespect) kept pushing. Forget the idea that blacks are outside of any system—we are the system. I guess that many people outside of the arts have awakened to the day and age and moved on. It seemed like Afrofuturism just didn't have a cohesive situation to have music, art, and literature evolve from. Sure, Afrofuturism can be used, as you put it , as a word like jazz, hip-hop, deconstruction, or philosophy itself, but only by sleight of hand (which is sampling, anyway). It's basically a hall of mirrors, a smoke and fog routine in a middlebrow cheap magic show. But hey, even that can be interesting sometimes.

I like to think of mix tapes and collage aesthetics as being two sides of the same devalued coin. In this scenario, an album isn't really an album: it's a manifesto about the place of history in our modern collaged, scrambled, sampla-delic, info-overloaded, digital culture. With references stretching from Thorstein Veblen's *Theory of the Leisure Class* and John Maynard Keynes' *The General Theory of Employment, Interest, and Money* over to hip-hop's relationship to psychoanalysis and the manufacture of consent, the concept of the mix album is a groundbreaking meditation on hip-hop and electronic music's relationship to philosophy, economics, and the science of sound in a world where the steady drumbeat of the

financial meltdown has made music the last refuge of young people with less and less time and money. My peer group of artists—like Rob Swift, DJ Krush, DJ Shadow, Cut Chemist, RJD2, DJ Logic, Amon Tobin, and Coldcut—have all played with the idea of concept albums. I love the way that artists like Saul Williams, Nine Inch Nails, and Radiohead have played with open-source distribution. They're just catching up to DJ culture. Ditto for the art and literary worlds. Science was there ahead of everyone.

Is Afrofuturism only an arts movement? And, what can art mean in the twenty-first century? What is at stake when Afrofuturism is thought in terms of art? What happens to art when it meets Afrofuturism?

I never really thought of myself as belonging to an arts movement. I think of Afrofuturism as an osmotic strategy machine. It absorbs other strategies, replaces them, viral-like, and reintroduces the genetic sequence back into the host. Arts movements are usually way too European. My faves are stuff like the Tropicalismo movement out of Brazil, which questioned the very foundations of what it meant to be a person of color in a high racist society. Art should say "these dreams are possible." To me, the major issue we face in the twenty-first century is the basic fragmentation of almost every solid point of reference. Why do people believe Rush Limbaugh? Would an art movement be able to inspire that kind of blind (and bland) devotion? Sure. But what makes Afrofuturism interesting is that it simply defies categorization. I think of my artwork and music as panhumanist. If you compare Aimé Césaire's *Négritude* with Yambo Ouologuem's *Bound to Violence* and see the ease with which Ouologuem's work was dismissed because he plagiarized (nobody would blink an eye in this day and age of cut-and-paste aesthetics), you can see the uneasy tension that literary and arts movements based on ideology possess: the tools in our era continuously change, and so too the categories of judgement, and the criteria of quality. It's all super ambiguous. I kind of dig that.

How is the "futurism" in Afrofuturism connected to the Futurists? Is this representative of a historical moment, a connection between Afroamerican artists working in a certain time and mode and connecting to Futurism? Or is it a connection that has been made in retrospect, on a theoretical plane, as a way of connecting futurism to Russolo's and his *Art of Noises*?

There's an African American pianist named Blind Tom Bethune who was one of America's premier pianists after the Civil War. You could say he was black America's first rock-star jazz musician. He knew how to simulate the sound of cyclones, storms, and even large battles. His composition *The Battle of Manasas* was meant to evoke the large scale of the Civil War, and the way machines churned out automatic death. I look to earlier things like the origins of robotics in the idea of the "automaton" and the develoment of an algorithmic way of looking at the city. In fact, I always enjoy bringing this up, the term "alogorithm" is derived from al-Khwārizmī, a Persian mathematician and astronomer from the ninth century. His books were also a source for the term "algebra," so the idea of a mathematics of the city goes a lot deeper than the

Futurists. They just got the media hype. Afrofuturism, in my mind, is a kind of inverse mirror where Europe and Africa collide, and the rest of the world watches in awe. But yeah, musically, Luigi Russolo's 1915 manifesto *The Art of Noise* is probably the basic DNA connection, and there's Valentine de St. Point's feminist *Manifesto of Lust* that was written against Marinetti's fascination with machines. She celebrated the human body. Things like that inspire me. The connection between Afrofuturism and the Futurist movement is there, if you're looking for stuff like Professor Griff from Public Enemy being called a fascist, or stuff like that, too.

What about the fascist politics of Futurism? How does that play into the Afrofuturism? What is to be done with it?

Rebirth of a Nation is DJ mixing applied to cinema. Don't forget that cinema has the same word root as kinetic. It's been 100 years since Filippo Marinetti wrote his infamous *Manifesto of Futurism* and even more since Ferruccio Busoni wrote his essay Sketch of a New Aesthetic of Music. What has changed in the world since those two essays were written? For one thing, we've finally come to terms with seeking some kind of balance between noise, rhythm, and repetition. We've opened our ears to the sound of the world around us in a way that composers and artists of the last century would have found extremely difficult to come to terms with. Think of Russolo's *The Art of Noises*, where he writes, "let us cross a great modern capital with our ears more alert than our eyes and we will delight in distinguishing the eddying of water, air, and gas in metal pipes, the muttering of motors that breathe and pulse with an indisputable animality, the throbbing of valves, the bustle of pistons, the shrieks of mechanical saws, the jolting of trams on the tracks, the cracking of whips, the flapping of awnings and flags. We will amuse ourselves by orchestrating together in our imagination the din of rolling shop shutters, slamming doors, the varied hubbub of train stations, iron works, thread mills, printing presses, electrical plants and subways." Try doing that on a plantation.

Title from Paul D. Miller's *Rebirth of a Nation*.

What is the parallel of Afrofuturism? Isn't piracy widespread, and remixes the norm of the computerized youth? Or are you making covert claims that most artists bank on copyrighting their remixes, in a paradoxical movement to legitimize and monetize sampling? Is this limited to the arts, or is this a broader moment, a failure to meet the Afrofuturist promise?

My favorite artists are people like David Hammons, Duke Ellington, Liebniz, Julie Mehretu, Blind Tom Bethune, Mos Def, Anti-Pop Consortium, everything that the Afropunk scene is up to, Santigold. One of the main issues I always see in arts movements is a kind of informal Apartheid between use-practice in the everyday world and the basic sense of theory and ideas that drive the art movement agenda. The theoretical constructs that many of the participants use to frame discourse around how digital media and politics intersect is very rarely tied to the real world. Think of Paul Virilio and Charles Sanders Peirce's "logic of pragmatism"—I would bet they wouldn't have listened to Duke Ellington, even if they could. Just a guess.

What kind of response is Afrofuturism to the history of slavery? To a history of forced labor? Where does automation fit into this, especially in the twenty-first century, and in the development of Afrofuturism as a practice that reshaped property, robot mythology, and automation in the misuse of technologies (turntables, synthesizers, recording archives)?

For me, in the hip-hop era, we need to look back at some precedents in the avant-garde. George Antheil's *Ballet Mécanique*; Erik Satie's music of modal repetition; the serialist movements of Arthur Shoenberg, Anton Webern, and Pierre Boulez; the electronic tape manipulations of the Arab composer Halim el-Dabh; the studied, delicate balance between Eastern and Western tonal structures of Debussy's *La Mer*; the density of India's traditions of formal compositions in Ravi Shankar; the paradoxical innovations of Olivier Messiaen and Edgard Varèse. All of these find a home in repetition. Hip-hop, house, techno, all demand a kind of "participation mystique." Ditto for essays like Emerson's infamous "Of Quotation and Originality." He uses the term "massive debt" to talk about the credit owed to history for any new innovation.

I like to think of some of the issues I've seen develop in what was called Afrofuturism about play and labor as a strange dialectic between known forms of labor and their evolution into other "unknown" forms like the social accumulation of knowledge, the discursive space of DJ mixes, the fragmented codes people use to foster temporary autonomous zones made of real-time interaction. Above all, Afrofuturism, for me, was irreverence for almost any standard form of representing ethnicity, class, originality or any kind of limitation on what it means to be a human on this messed up planet we all call home. We're all Afrofuturists, because, put simply, we all participate in a post-colonial, neo-Darwinian paradox of evolution. Some traits and characteristics simply aren't inherited: they have to be force marched into something that absorbs all the old forms of thinking and creates a space in culture where something new can happen. There really isn't anything new. If we go back to the original Futurist movement, you can see the seeds of our current moment: it was a movement widely seen as being based on music. From Ferruccio Busoni's 1907 essay "Sketch of a New Aesthetic in Music" to Luigi Russolo's *The Art of Noises*, we've been seeing how the various art movements of the beginning of the twentieth century appropriated African, Asian, and African American motifs. America has been trying to catch up ever since. That is our inheritance.

A techno-turntablist and interventionist in the offplanet arts since 1993, tobias c. van Veen has a doctorate in Philosophy and Communication Studies from McGill University, Montréal. His edited volume *Afrofuturism: Interstellar Transmissions from Remix Culture* is available from Wayne State University Press.

ABOUT THE AUTHOR

Paul D. Miller, a.k.a. DJ Spooky, is a composer, multimedia artist, and writer. He has written for publications including The *Village Voice*, *The Source*, *Artforum*, *Aperture*, and *The Wire*. Miller's work as a media artist has appeared in international venues, including the Whitney Biennial; The Venice Biennial for Architecture; the Ludwig Museum in Cologne, Germany; Kunsthalle, Vienna; The Andy Warhol Museum in Pittsburgh; and many other museums and galleries. Miller published a collection of essays, *Rhythm Science* (MIT Press, 2004) and edited *Sound Unbound* (MIT Press, 2008), an anthology of writings on electronic music and digital media. He has collaborated with artists as varied as Yoko Ono, Lee "Scratch" Perry, Thurston Moore, and Chuck D.

The multimedia performance piece about Antarctica, *Terra Nova: Sinfonia Antarctica*, was commissioned by BAM for the 2009 Next Wave Festival; The Hopkins Center/Dartmouth College; UCSB Arts & Lectures; Melbourne International Arts Festival; and the Festival dei 2 Mondi in Spoleto, Italy. *The Book of Ice* is a component of this work, which serves as a portrait of a rapidly transforming continent.

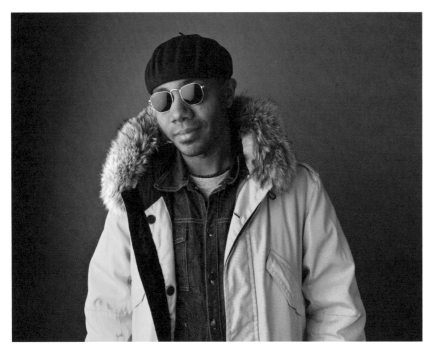

Photo courtesy of Mike Figgis.

ACKNOWLEDGMENTS

As with any book, this project has been a collection of impressions. Some of the best conversations I've had about environmental issues have been with the following people and I'd like to thank them for their candor and feedback:

My mom, Rosemary E. Reed Miller, and my sister, Sabrina Miller.

Steve Cohen, Peter Fleisig, Ryuichi Sakamoto, Steve Reich, Moby, Thurston Moore, Yoko Ono, Pamela Puchalski, The Canary Project, Janna Olson, Mitchell Joachim, Andrew Aenoch, Ali Hossaini, Naeem Mohaiemen, Ravi Naidoo, Lucy Walker, Annie K. Kwon, Roselee Goldberg, Lukas Ligeti, Damon Dash, Claire Tancons, Alison Chernick, Mie Iwatsuki, David ADJaye, Catherine Corman, Zina Saro Wiwa, Shinique Smith, Aviv Eyal, Dan Yashiv, Roy Brand, Wolfgang Schirmacher, Tanya Selvaratnam, Jimmy Wales, Jill Mikucki, Earth Institute, Robert Miller Gallery.

Additional credits

Reproduced photographs are in the public domain unless otherwise noted. Additional images have been licensed, royalty-free. Image on page 11 is © Andre Câmara. Images on pages 26, 27 (top) © Rodrigo Torres. Page 27 (bottom) © Diana Sandes.

Infographics on pages 7, 23, 51, 54, created and remixed by ænoch.

MAP (Manual of Architectural Possibilities) 001 ANTARCTICA on pages 88-91 © David A. Garcia (www.davidgarciastudio.com)

Special thanks to the State Library of New South Wales, who provided many of the historical hi-res image scans.

Library of Congress Control Number: 2010941685

Printed and bound in China through Asia Pacific Offset

10 9 8 7 6 5 4 3 2 1 First edition

This edition © 2011
Mark Batty Publisher
68 Jay Street, Suite 410
Brooklyn, NY 11201

www.markbattypublisher.com

ISBN: 978-1-9356131-4-5

Distributed outside North America by:
Thames & Hudson Ltd
181A High Holborn
London WC1V 7QX
United Kingdom
Tel: 00 44 20 7845 5000
Fax: 00 44 20 7845 5055
www.thameshudson.co.uk